IMAGES
of America

CAPE CANAVERAL

IMAGES
of America

CAPE CANAVERAL

Ray Osborne

ARCADIA
PUBLISHING

Published by Arcadia Publishing
Charleston SC, Chicago IL, Portsmouth NH, San Francisco CA

Printed in the United States of America

Library of Congress Catalog Card Number: 2007934719

For all general information contact Arcadia Publishing at:
Telephone 843-853-2070
Fax 843-853-0044
E-mail sales@arcadiapublishing.com
For customer service and orders:
Toll-Free 1-888-313-2665

Visit us on the Internet at www.arcadiapublishing.com

Dedicated to my sweetheart, Gail Galt. Her encouragement and support made this book possible. Our love will continue past this earthly lifetime. "Love endures forever."

CONTENTS

ACKNOWLEDGMENTS

The author would like to acknowledge the following organizations and individuals for their sincere efforts to contribute to the creation of this book. Indeed this book is a cocreation of people helping people.

Air Force Space and Missile Museum Library
Brevard Historical Commission (attributed throughout as BHC)
Brevard Museum of History and Science in Cocoa
Cape Canaveral Lighthouse Foundation (attributed throughout as CCLF)
City of Cape Canaveral (attributed throughout as CCC)
Florida Historical Society
NASA at Kennedy Space Center Archives
North Brevard Historical Museum (attributed throughout as NBHM)
Port Canaveral Authority
East Coast Surfing Hall of Fame Museum
Ted Morris—Florida Lost Tribes Exhibit
The 45th Space Wing History Office
U.S. Space Walk of Fame

Special thanks goes to those individuals who spent their time and effort helping provide images from their collections and helping with accurate caption material for this book: Terry Armstrong, Roger Combs, Roger Dobson, Nonie Fox, Gail Galt, Al Hartmann, Jim Morgan, Ted Morris, Flossie Staton, Ann Thurm, Sonny Witt, and Gary and Carolyn Zajak.

There is no greater joy than to see people come together and share their stories, their photographs, and their encouragement. It is wonderful to see surprise and delight on people's faces and to learn or share some old forgotten story about our heritage. The author would like to thank those unmentioned people who referred him to others. All too often in restoring our history, we learn that we are too late or an adult child wishes they had heard more about local history from their parents, who are now deceased. It is important that not only should people try and communicate better but to also season it with grace and patience.

Finally the author would like to acknowledge all the other writers, journalists, and publishers who wrote and published insights into this local history. Wherever appropriate, the author acknowledges his sources in the actual caption of each photograph.

"If I have seen farther it is by standing on the shoulders of giants."

—Sir Isaac Newton

INTRODUCTION

The history of Cape Canaveral is one that goes far back into the distant past when early European explorers in wooden ships would map the coast of Florida and note this land jutting out to the sea. Many times, ships would wreck upon the shoals, dumping their cargo, which in turn supplied a small community with necessary supplies. This was an area full of drama—from Ribault's Frenchman in 1565 building a fort at the cape for protection from the Spanish to Spanish galleons laden with gold and treasure that passed by the cape to head back to Spain. This is also a story of refinement in the Gilded Age as it was a place to bring out America's best, a 19th-century Ivy League alumni class who built a "hunters club" in the wilderness and helped clear the way. The name of Cape Canaveral is preserved on ancient maps and was transmitted over busy teletypes and newspapers, splashed across their headlines all over the globe regarding hot news of the latest daring rocket and space activities.

Cape Canaveral has been the place of landing for many distinguished visitors, including presidents, pirates, princes, scholars, entertainers, and captains. In this book, we explore the lesser-known people, the folks who may not have gotten much attention in the past. A special emphasis has been made to uncover new information on subjects long forgotten. Myths and folklore are kept intact and preserved, as they serve an invaluable function in the transference of historical tales from one generation to another. Oral histories are recorded to bring to literary life a people long gone but who left their footprint in the sands of time on the Cape Canaveral shore.

Cape Canaveral is a "field of dreams," some realized—like Port Canaveral and the Space Center—and others that failed—like the towns of Canaveral Harbor and Journalista and even a museum of sunken treasure. The rich prehistory of Cape Canaveral is preserved in the Native American mounds called middens, where artifacts of an ancient race can be found. Throughout the years, archaeologists have not only uncovered ancient pottery but also metal jewelry from these peoples.

The author invites the reader into a journey through time. Hopefully this is a book to give the reader a taste for more to come. Special attention has been given to keywords so the readers may further their learning and discovery experience by using popular Internet search engines.

Read and enjoy.

—Ray Osborne

ABOUT THE AUTHOR

Raymond (Ray) K. Osborne was born in Huntington, England, on November 4, 1953. He immigrated to the United States when he was three years old and grew up in various places on the Eastern Seaboard. He developed a passion for writing while serving in the U.S. Navy by writing articles for the ship's newsletter. Many years later, he wrote technical articles in Atlanta, Georgia, and then finally moved to the Cape Canaveral area in 1996 where he developed a deep appreciation but also concern for preservation of the area's history. As a freelance writer, he is a correspondent for the local newspaper *Florida Today* and has a history column with *Senior Life* magazine. Ray Osborne holds history seminars, which bring history alive to the public, and he welcomes speaking engagements. Ray is working with new media development and believes it is imperative that we preserve old history into new media. He welcomes the reader to visit his Web site at www.RayOsborne.net, where more information about local history can be found, and visit www.capehistory.info for more information about Cape Canaveral.

One

TALES FROM THE CAPE

TREASURE OF THE CAPE. The real treasure of any community is its heritage and history. Cape Canaveral is rich with tales and stories that include all kinds of treasure. These coins are from the 1715 wrecked treasure fleet, some of which may lay off the shore of Cape Canaveral. In this chapter, learn about this unique community and how it became a name recognized worldwide. The Spanish gold found off the east coast of Florida is one of many exciting legends of the area. A fleet of 12 Spanish treasure ships known as the Spanish Plate Treasure Fleet left Havana, Cuba, in 1715, and all but one were wrecked during a hurricane. These ships spilled their precious cargo of treasure along the central eastern Florida seaboard south of Cape Canaveral. However, some treasure experts believe that shipwrecks from this fleet may be off the immediate coast of Cape Canaveral, but nevertheless, some of the 1715 treasure did end up in a brand-new Cape Canaveral Museum of Sunken Treasure in 1967. (Del Long.)

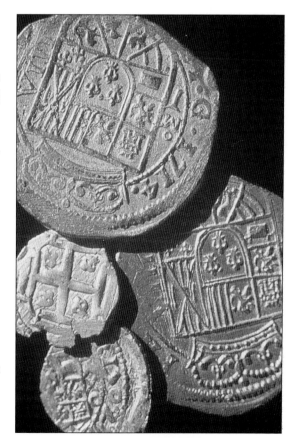

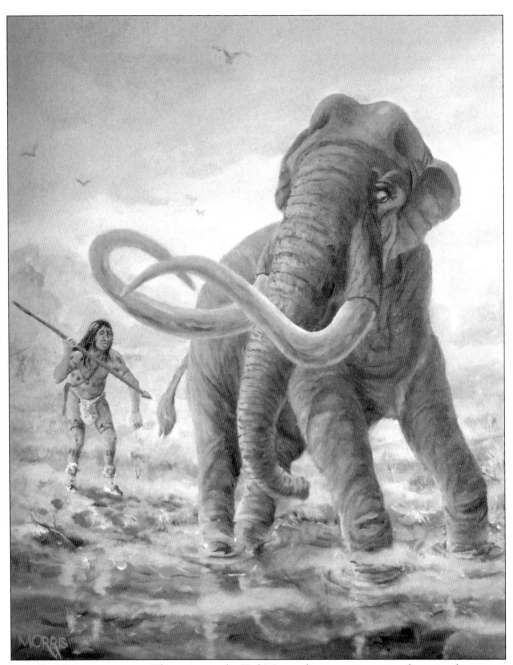

THE FIRST INHABITANTS. This painting by Ted Morris demonstrates an early native known as a Paleoindian attacking a Florida mammoth. From Melbourne to Titusville, ancient skeletons have been found of animals ranging from mammoths and saber-tooth tigers to giant armadillos. Cape Canaveral is an area rich in archaeology, and artifacts found in neighboring Titusville are over 6,000 years old.

Ais Indians. In the 17th century, the early Spanish called the local natives Ays or Ais Indians. In this painting, artist Ted Morris takes clues from early European explorers to paint what a local Ais Indian would have looked like. The artist includes an ornament of a silver cross around his neck. This item was found in a 1920s archaeological dig in a place called the Burns Mounds. Artifacts such as this were found during a number of visits from students and professors from schools and museums in the Northeast. (Ted Morris.)

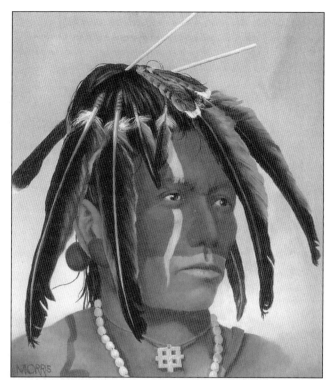

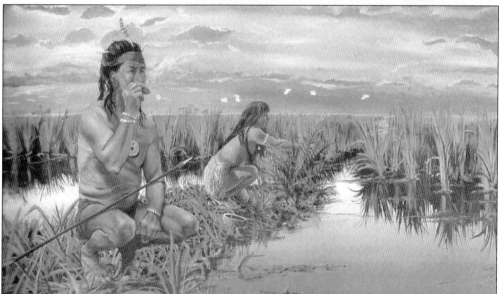

The First Inhabitants of the Cape. The very first residents of Cape Canaveral were the natives. Evidences of early local people are found in archaeological surveys and the writings of the early European explorers. Early written accounts reported that the indigenous people of Cape Canaveral were hunters and gatherers and would leave the cape during certain times of the years because of the stinging insects. This picture depicts fields that may be of cane. Early explorer and ship's journal writer John Sparke aboard Master Johns Hawkins's ship wrote that the Native Americans would smoke an herb, perhaps tobacco. (Ted Morris.)

PONCE DE LEON. The Spanish explorer Ponce de Leon is credited with discovering Florida in 1513. There are many legends and folklore about Ponce de Leon. One famous myth that children learn is that he was seeking the mythical Fountain of Youth. Most historians believed that, like most Spanish explorers, he was looking for gold and slaves. Some opinions state he landed in the area (perhaps Melbourne Beach); others state that he sailed past Cape Canaveral. One tale is that the Spanish royal historian onboard his vessel, Antonio de Herrera, named Cape Canaveral "Cape of the Currents." Sailors later called it "Plantation of Canes" or "Place of Tall Reeds." The name Canaveral can be found on early maps.

FRENCH MAP. Frenchman Laudonniere is pictured in 1565. A French Florida? History may have been different for Florida if it had not been for subtle changes in circumstances. A local legend says a fort was built from the timbers of a French ship, the *Trinite*. An entry in Irving Rouse's 1951 Yale University publication *Indian River Survey* reads, "Ribault was on his way to reinforce a French colony which had been established by Laudonniere at the mouth of the St. Johns River in 1564. Considering this colony a threat to the route of the treasure ships, the king of Spain ordered Admiral Pedro Menendez de Aviles to destroy it, which he did in the autumn of 1565 soon after the arrival of Ribault, setting up in its place a Spanish colony at St. Augustine. Some of the Frenchmen fled southward to Cape Canaveral, where they built a fort and attempted to construct a ship in which to return to Spain." The account continues and states that Native Americans allied with the Spanish told Menendez and he pursued the refugees, destroyed their fort and boat, and captured all except their captain and some others who escaped into the wilderness.

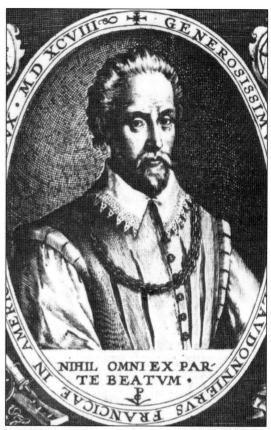

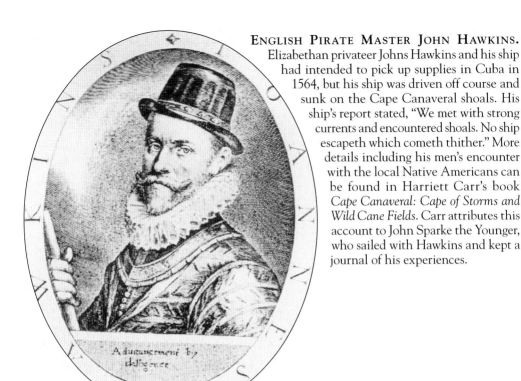

ENGLISH PIRATE MASTER JOHN HAWKINS. Elizabethan privateer Johns Hawkins and his ship had intended to pick up supplies in Cuba in 1564, but his ship was driven off course and sunk on the Cape Canaveral shoals. His ship's report stated, "We met with strong currents and encountered shoals. No ship escapeth which cometh thither." More details including his men's encounter with the local Native Americans can be found in Harriett Carr's book *Cape Canaveral: Cape of Storms and Wild Cane Fields.* Carr attributes this account to John Sparke the Younger, who sailed with Hawkins and kept a journal of his experiences.

SPANISH REINFORCEMENTS. Pedro Menendez, the governor of St. Augustine, set about to reinforce Spain's stronghold on Florida by building a fort at Canaveral. The local Native Americans who favored the Spanish (the Ais) allowed them and also helped the Spanish with their struggles against the other European military units. Menendez called his fort Santa Lucia de Canaveral. Some historians believe that this fort was closer to the area of Sebastian than the cape, however. Other historical reports indicate that in 1566, Menendez had watchtowers built at Cape Canaveral and Biscayne Bay to keep a protective watch over the Spanish plate fleets that were transporting treasure from the New World back to Spain. It was written that part of Menendez's success was that he was able to befriend the Ais Indians and get them to be an ally against the other European armies. (Karen Harvey.)

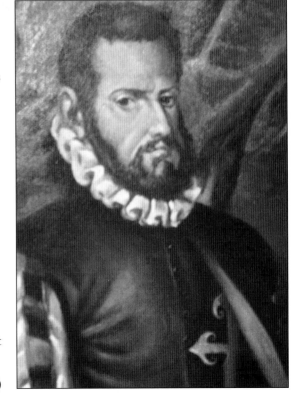

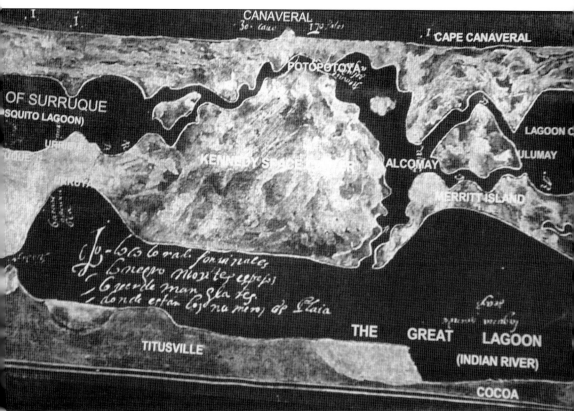

ALVARO MEXIA'S MAP ADAPTED WITH ACTUAL PLACE NAMES. Spanish soldier Alvero Mexia, on orders from his garrison leader in St. Augustine, Florida, came to map the area in 1605. A detailed account of Mexia's travels was translated and published in Irving Rouse's 1951 Yale publication *Indian River Survey*. A chapter of Rouse's said Mexia's writings were "a handy and useful guide which describes truthfully in every detail the rivers, channels, lagoons, woodlands, settlements, harbors, shoals and camps from St. Augustine to the Bar of Ais." Interestingly, it includes an account of a letter written to the King of Spain stating that Mexia was befriended by the local Ais Indians and made a chief by them. Many anthropologists would argue about this statement as they say the Ais would never make a white man a chief. (Terry Armstrong.)

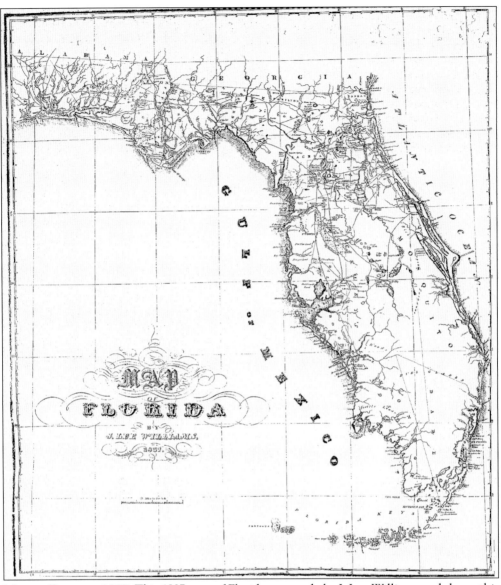

MAP OF FLORIDA, 1837. This 1837 map of Florida was made by J. Lee Williams and shows this area, currently Brevard County but then called Mosquito County. This map accompanied a book entitled *The Territory of Florida, Or, Sketches of the Topography, Civil and Natural* by J. Lee Williams. The map was lithographed by Greene and McGowran in 1837. A copy of the very rare map was included in the donated collection from Marjory Stoneman Douglas to the University of Miami. The map shows that Florida was sparsely populated with few towns, but the accompanying book gives invaluable insights into Florida history. A logical explanation of the origin of the name Merritt Island is written. The author writes of Meritts (notice one *R*) Island that lies west of Cape Canaveral and the mention of a plantation started by a Mr. Meritt. The author gives credit to Florida's first European explorer, John Cabot, for sailing all of the eastern shore of Florida in 1498. (Gary and Carolyn Zajak.)

CAPT. JOHN BARRY. Capt. John Barry and his crew of the *Alliance* fought the final naval battle of the American Revolution off Cape Canaveral on March 10, 1783. Six months later, the Treaty of Paris was signed to officially end the Revolutionary War. It is reported that the captains' logs from both the *Alliance* and the HMS *Sybil* report the name of Cape Canaveral in their entries. (Lindsey Brock.)

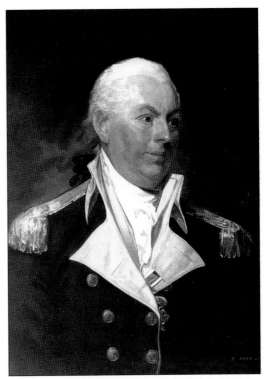

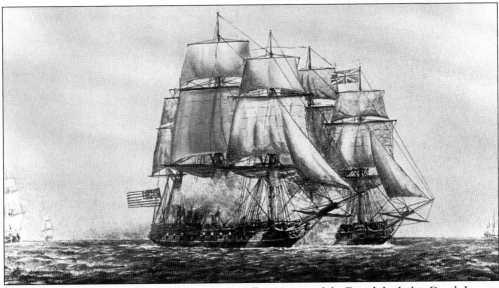

THE AMERICAN FRIGATE. The American frigate *Alliance* escorted the French-built ship *Duc de Lauzun* from Havana carrying the payroll of the Continental army. A payroll of Spanish silver dollars in the amount of $75,000 was being transported to the World Bank in Philadelphia. The ships were challenged by three British ships led by the HMS *Sybil*. An intense battle ensued, resulting in a broadside attack where the British were incapacitated. The *Alliance* had 3 killed and 11 wounded, and the British had 37 killed and 50 wounded. Near this date in history, a ceremony is held every year. This watercolor of the *Alliance* versus the *Sybil* is from the Bailey Collection at the Mariner Museum in Newport News. (Lindsey Brock.)

HARVARD AT THE CAPE. A hunting club called the Harvard Canaveral Club was started by the 1890 graduating class of Harvard University. The property boundaries encompassed some 18,000 acres; a three-story, 20-room clubhouse; rooms for members and guests; a trophy room; a well-stocked wine cellar; ammunition storage; a large dining room; a swimming pool; boathouses; and servant quarters. The club had its own shallow-draft steamboat called the *Canaveral* and a yacht called the *Yankee Doodle*. (NBHM.)

THE HARVARD CANAVERAL CLUB (WEST VIEW). This was the life of the wealthy upper class. Located adjacent to the Atlantic Ocean and Banana River, the club exemplified the life of the wealthy during the Gay Nineties. Currently Launch Pad 39 B for the *Saturn V* is located on this site. Many decades later, other VIPs visited this location to watch *Apollo 11* and its historic launch. (NBHM.)

SWIMMING POOL.
The first guest to sign the register was Charles Cory, with wife, child, and maid. Cory and 11 other members of the 1890 class were owners of the club. There was a membership fee of $5,000, and members were limited to only 14. Their purpose was to increase tourism to the area. Entertainment included fishing, hunting, boating, horseback riding, and swimming. The swimming pool is claimed to have been the first in the southeastern United States.

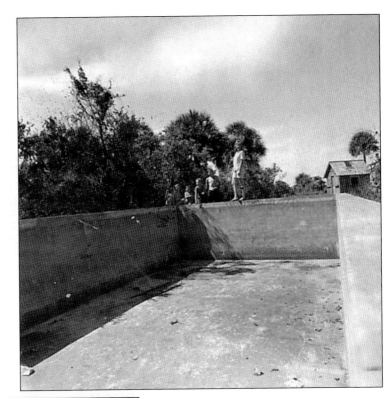

BEAUTIFUL FURNITURE. There were oral histories that this club had many beautiful furnishings. These artifacts may have ended up in private collections; they are hard to find. The Brevard Historical Commission reported in their book *History of Brevard County, Volume I* that Presidents Benjamin Harrison and Grover Cleveland were prominent visitors to the club. After Grover Cleveland's 1888 Florida visit, he became a frequent visitor to Florida and was a fine sportsman. Other guests of the club included Sear, Horton, Perry, Winslow, Fay, Weld, Browne, and Count Arco of Berlin. Club managers were George H. Reed and then Eben Dorr. (NBHM.)

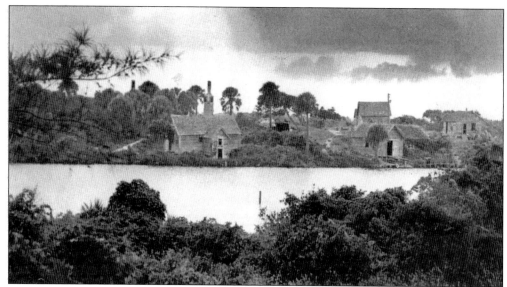

HARVARD IN FLORIDA. A partnership was formed by some graduates of the 1890 class whereby a declaration of trust signed by Alexander Cochran (Boston and New York) and Howard J. Jefferson Cotridge. Other owners included Charles P. Horton, F. L. Higginson, Francis W. Sergeant, Charles Cory, Fredrick Amory, Stephen M. and Charles Field, and Von Longerke Meyer. In the document, they agreed, "This trust shall be continued during the life of the longest lived of the Harvard graduating class of 1890." (NBHM.)

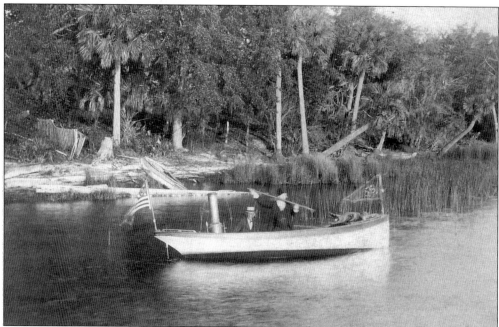

BOATING AND HUNTING ON THE BANANA RIVER. Although it is uncertain if this picture is of members of the Harvard Canaveral Club, there are strong indicators (such as fashion) that it is. The Harvard Canaveral Club served the beginning development of the Banana River well in that their hunting reduced the number of dangerous animals. Not only were there alligators to watch out for, but there were rattlesnakes, bears, and panthers as well. (Doug Hendriksen.)

Two

LIGHT AT THE CAPE

LIGHTHOUSE WITH PALM TREE. According to local history, the lighthouse did more than shine its lights for passing ships; it also became a hive of social activity. Lighthouse keepers were the rock stars of their times and would often entertain notable visitors. Both local and national newspapers have reported the visits of notables to the lighthouse keeper. An article in the *Boston Daily Globe* reported on April 24, 1877, about the visit of English nobleman Sir Francis Sykes to Mills Burnham. This English nobleman owned a hunting lodge at New Found Harbor in Merritt Island. Sykes did some archaeological work at Burnham's Grove and removed artifacts and skeletons from a Native American mound. The artifacts were sent off to the British Museum in London, England. (NASA at KSC.)

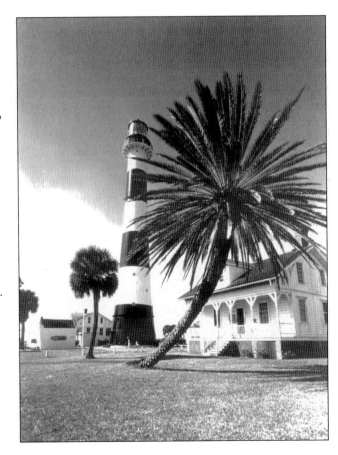

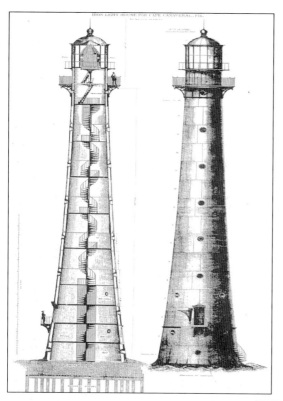

SECOND LIGHTHOUSE MADE OF IRON. The historic newspaper *Florida Star* had a descriptive story on November 18, 1885. The story, entitled the "Cape Canaveral Region," reported, "This handsome tapering structure, known as 'Cape Canaveral Light,' stands within a few feet of the water's edge at the extremity of the cape. It is 165 feet above sea level and went into operation on June 5th, costing in the neighborhood $480,000. The Tower is built on solid stone cement foundation, is fifty six feet square, nine and half feet deep, to which the superstructure is fastened with seventy-two bolts, each five feet in length. At the base, the tower is 33 feet in diameter and 12 feet at the lantern." (NBHM.)

KEEPERS OF THE LIGHT. The first lighthouse keeper was Nathanial Scobie, and the second was Ora (Williams) Carpenter. Both served short terms because of hostile Seminole Indian activity in the area. Mills O. Burnham, the third lighthouse keeper, served the longest and is best known. Born in Thetford, Vermont, on September 8, 1817, he worked as a gunsmith. He moved to Florida in 1838, homesteaded his land under the Armed Occupation Act, and is the considered first settler of the Cape Canaveral area. At his Cape Canaveral grove, he planted a number of crops, including pineapples, sugar cane, guava, and citrus. It was reported the sugar cane grew well for many years virtually unattended. He was appointed lighthouse keeper in 1853 and served until his death on April 17, 1886. (Nonie Fox.)

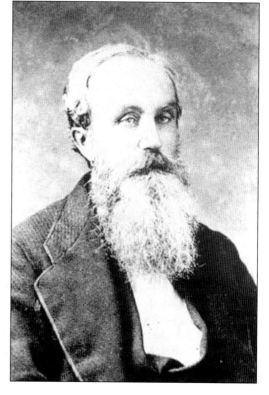

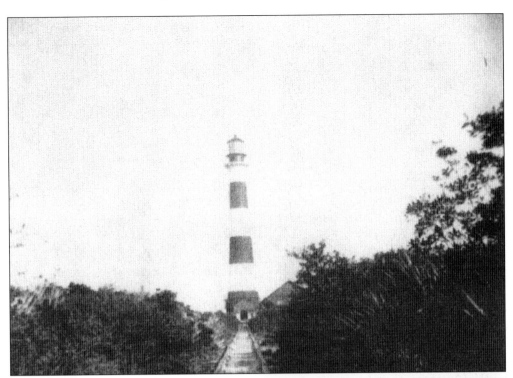

MOVING A LIGHTHOUSE. Tram rails can be seen heading to the lighthouse. It was reported these rails facilitated the moving of the lighthouse away from the encroaching beachfront. The tower was dismantled and transported approximately one mile inland using a rail cart pulled by mules. Local settler Wyatt Chandler moved to the area to assist in moving the structure. (45th Space Wing History Office.)

ARMY TO THE RESCUE: HENRY WILSON. Seminole Indian attacks in the area caused the government to send three soldiers to guard the lighthouse, one of which was Cpl. Henry Wilson. After it was decided there was no longer a danger, Wilson took his discharge from the army and became an assistant to Mills Burnham. On March 30, 1856, he married Burnham's daughter Frances in Trinity Episcopal Church in St. Augustine. Wilson served as postmaster for 30 years after his service as a lighthouse keeper. Frances and Henry Wilson had five daughters and two sons. Wilson was affectionately described in Robert Ranson's book as "The Living image of Santa Claus." (Nonie Fox.)

ALL IN THE FAMILY? "There have been born to the Capt. and Mrs. Burnham eight children, three sons and five daughters," read the *Florida Star* on September 10, 1885. This fascinating account about Captain Burnham's golden anniversary gives the reader an insight into this joyous family affair. There is a difference of opinions among historians regarding the number of sons and daughters, however. In a father-and-son outing on the lagoon, Burnham and his son George named the body of water next to Cape Canaveral the Banana River. In Robert Ranson's *A Memoir of Mills Olcott Burnham*, it was written that Mills and son George sailed from Merritt Island across from Eau Gallie up the East Channel, where they christened a blind pocket of water Newfound Harbor. Seeing two islands, they named one George's Island and the other Buck Point because of the many deer that was seen there. Ranson wrote that George died at about 14. Another of Burnham's sons, Mills Burnham Jr. (above left), served in the Confederate States army. Mills Jr. enlisted at Camp Lee, Leesburg, Florida, on April 11, 1862. He served in the 7th Florida Infantry. His service was short-lived, as he died in Chattanooga, Tennessee, of illness in June 1862 at the age of 19. The lighthouse keeper's daughter Catherine ("Kate") Burnham is seen at left around 1845. (Nonie Fox.)

LIGHTHOUSE KEEPER'S FAMILY. Shown here are Capt. Clinton P. Honeywell, Gertrude Wilson Honeywell, and their children, Gertrude, Florence, and Clinton Jr. ("Bud"). Captain Honeywell was a native of Baltimore, Maryland, and came to Canaveral to homestead government land in 1884. A few years after his arrival, he became connected with the Canaveral lighthouse as keeper and served in that capacity for 41 years, retiring in 1930. (Yvonne Thornton.)

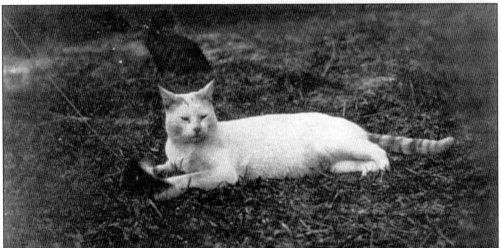

A TRUE SURVIVOR. Albert the Lighthouse Cat was no ordinary cat. Local folklore has it that he swam ashore to the cape from a sinking ship called the *Albert Sopha.* As this cat was a Turkish Van, it had the unique ability to swim. Oral history from a Honeywell descendant tells that Capt. and Mrs. Clinton P. Honeywell let the survivors of the ship stay at one of the storehouses on the lighthouse grounds. The next morning, Gertrude Honeywell gave the ship's crew a hot breakfast of oatmeal, and when they left, they gave the cat to the Honeywell girls, Florence and Gertrude. The daughters aptly named him "Albert" after the wrecked ship. This variety of cat, Turkish Van, is white with a touch of gold coloring. They originate from the Muslim Middle East, where an ancient tale states that this gold marking is where Allah touched it. (Yvonne Thornton.)

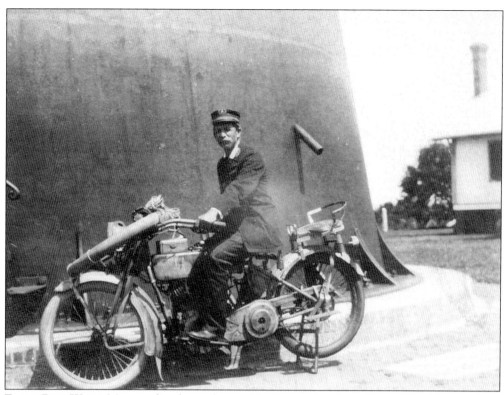

EARLY BIKE WEEK. Motorcyclists have always visited and enjoyed the Central Florida area. Here Clinton Honeywell poses with a visitor's Harley Davidson around the 1920s. Honeywell wanted a picture of himself on it. Clinton's wife, Gertrude, and Bud are on the porch; Florence was hiding underneath the porch because she was scared of the motorcycle. (Yvonne Thornton.)

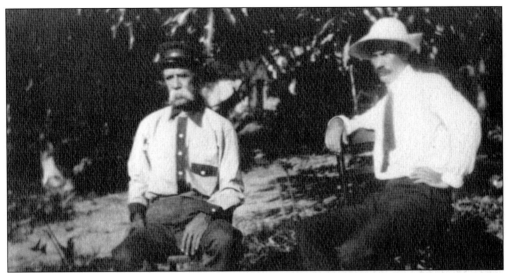

LIKE FATHER, LIKE SON. George Mills Quarterman and Oscar Floyd Quarterman were both lighthouse keepers. George Quarterman was married to Anna Dummitt Burnham, and Oscar married Florence Wilson on April 1, 1881. Florence was the daughter of Henry Wilson. Oscar Quarterman became head keeper of the lighthouse in 1929. The local paper, *Star Advocate*, reported the activities at the lighthouse on June 19, 1936. The story was "Lighthouse keeper Traps a Big Bear." Capt. Floyd Quarterman, in charge of the Canaveral Lighthouse, trapped the largest bear that had been seen recently in that section. The animal weighed 215 pounds and had been raiding beehives. (Nonie Fox.)

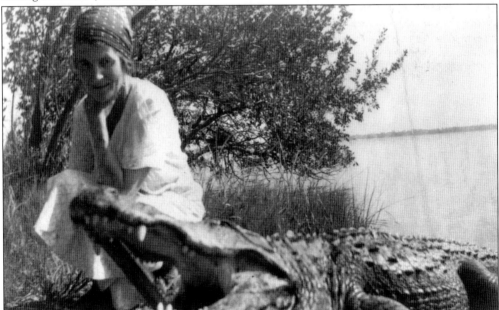

HOW ABOUT THEM GATORS. Gertrude Honeywell, daughter of the Clinton P. Honeywell family, poses with large alligator shot at Cape Canaveral. To no surprise, alligators could be a nuisance. Amos Cummings, a 19th-century journalist, wrote that Northern visitors should leave their pet dogs behind, as the dog barking would put these reptiles into a frenzy. He wrote that many a dog was eaten by these alligators. (Flossie Staton.)

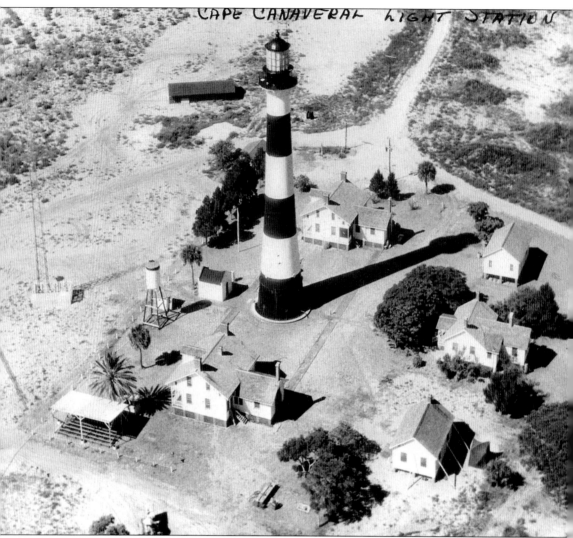

MORE THAN A LIGHTHOUSE. This is an aerial view of the light station. A light station is the complex that contains the lighthouse tower and all of the outbuildings. The outbuildings could include the keeper's living quarters, fuel house, boathouse, fog-signaling building, and a water tank/tower. (Air Force Space and Missile Museum Library.)

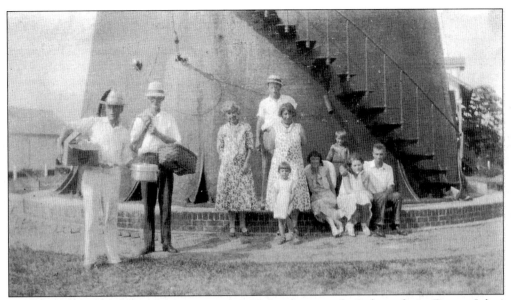

A GREAT PLACE FOR FAMILY OUTINGS. A multifamily picnic for Independence Day on July 4 1931, shows, from left to right, Sam Knutson, Wyatt Chandler, Bernice Chandler, Winks Chandler, Lorena Chandler Knutson, her child Nonie Knutson, Nellie and Wass Praetorius, and their two children. Floyd Quarterman was the brother of Bernice Chandler, and Wass Praetorius was the son of Florence Quarterman, who was married to Floyd Quarterman. The *Cocoa Tribune* reported on the July 4 celebration: "A picnic at the Lighthouse was enjoyed on the 4th by the families of Messrs. Quarterman, A. F. Hodge, Sam Knutson, Wyatt Chandler and Wass Praetorius." (Nonie Fox.)

THIS IS A TEST, ONLY A TEST. The lighthouse keeper would occasionally have new assignments. Here a number of American flags made of different fabric material are flown to test their durability against the elements at the cape. (Yvonne Thornton.)

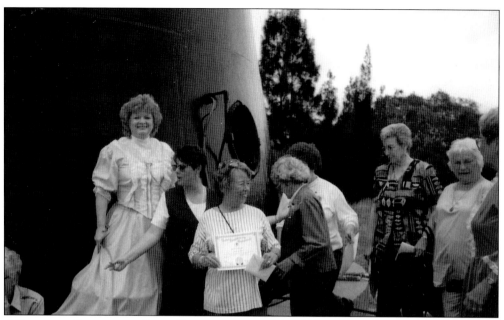

A PLACE FOR SOCIAL AND CIVIC ORGANIZATIONS. A local United Daughters of the Confederacy chapter held a reunion at the Cape Canaveral Lighthouse for Founders Day on May 18, 1998. The gathering included, from left to right, Sue Perry in period dress, Debbie Bensen, Glenda Walton, Jean Gayle, Jeanes Tornabene, and Bobbie Grine. A certificate of appreciation was presented to the lighthouse keeper. (United Daughters of the Confederacy.)

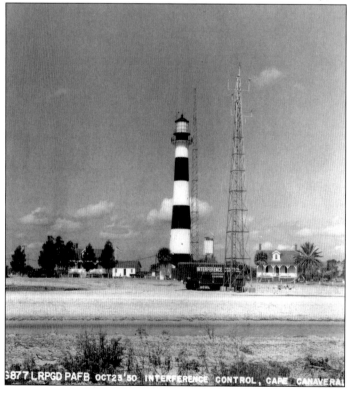

WATCH THAT ROCKET. Next to the lighthouse station, a radio interference vehicle can be seen that was used for early rocket and missile launches. The space industry made good use of the lighthouse tower. Local folklore stated that Wernher Von Braun would watch the rocket launches from the lighthouse. Another local tale goes that a new Pan Am employee was told to watch the black-and-white rocket that was about to go up; he strained to watch it for two hours when the silence was broken with howls of laughter from his colleagues. He was told that he was watching the 92-year-old lighthouse.

Three

"Old Days, Good Times I Remember"

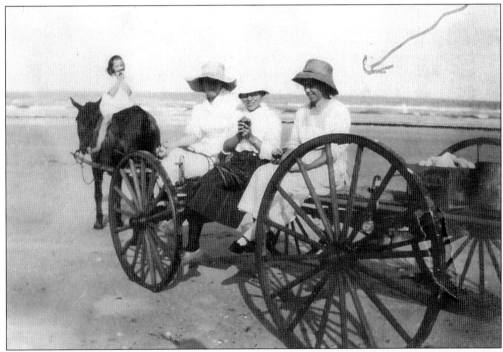

OLD DAYS OF CAPE CANAVERAL. Local settlers enjoy a sunny day at the beach. The settlers didn't always have a lot of money, but they had resources of fish, game, and land to grow a variety of crops. The Harvard Canaveral Club gave the area a measure of tourism from the rich and the promise that further development would pay off well. In the picture above, the Chandlers and family friends enjoy a day at the beach. The lady at far right is Bernice Chandler, Wyatt's wife. This is an original dune buggy on the sands of Cape Canaveral beach. (Flossie Staton.)

MYSTERY HOUSE, THE HALL PLACE. This house was owned by an early citrus grower in the Holman Road area of Cape Canaveral. There was an island called Hall Island close by and a road called Hall Road. In the book *The Winter Sailor,* edited by Francis Stebbins, it is written, "Mrs. J. C. Hall and her daughter from Boston had a six acre grove which often appeared on lists of noteworthy citrus plantations on North Banana River. She advertised both fruit and nursery stock." This information was published in "Groves for Sales" in the fall issue of 1884 FLAS by Southern Publishing. Oral histories say many birds would land on this island before they were shot and killed off by the local residents. (Flossie Staton.)

WYATT CHANDLER ("GUMPY").
Don't let the fish net fool you!
Wyatt was mainly a farmer, but no
doubt he did some fishing. Wyatt
was involved in the community;
he helped move the lighthouse in
1890 and was a caller for the local
square dancing group. The *Cocoa
Tribune* newspaper often reported
on his activities. (Nonie Fox.)

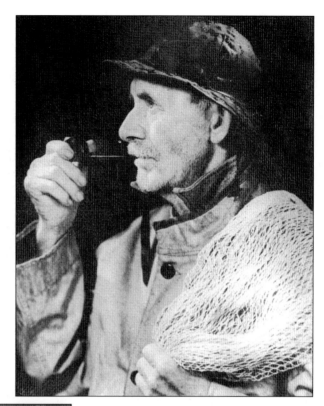

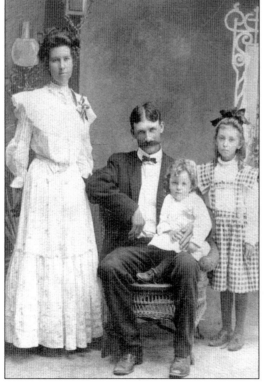

THE CHANDLERS. Bernice and Wyatt
Chandler are shown with their son, George
Wilkerson, and daughter, Lorena. Lorena
later became a Knutson through marriage.
George started a mobile home park called
Celestial Park to help house the employees
of the new missile industry. (Nonie Fox.)

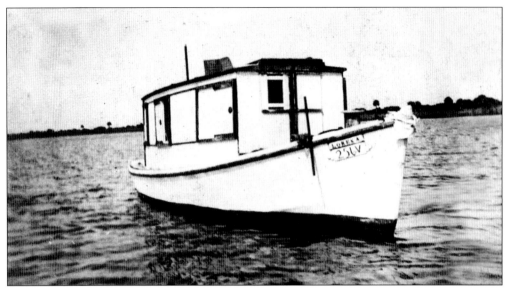

A BOAT CALLED LORENA. In the early days, there were no bridges, so the only way for the settlers to get to the mainland was in small boats. Not only did they serve as transportation, but they also provided the opportunity for fun-filled fishing trips. No doubt a sizable fish landed on the deck of this boat. Here is a picture of the Chandlers' family boat named after their daughter, Lorena. (Nonie Fox.)

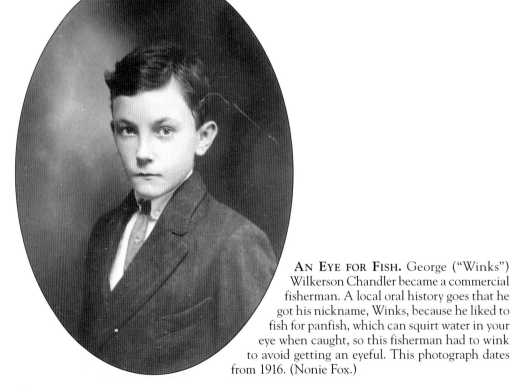

AN EYE FOR FISH. George ("Winks") Wilkerson Chandler became a commercial fisherman. A local oral history goes that he got his nickname, Winks, because he liked to fish for panfish, which can squirt water in your eye when caught, so this fisherman had to wink to avoid getting an eyeful. This photograph dates from 1916. (Nonie Fox.)

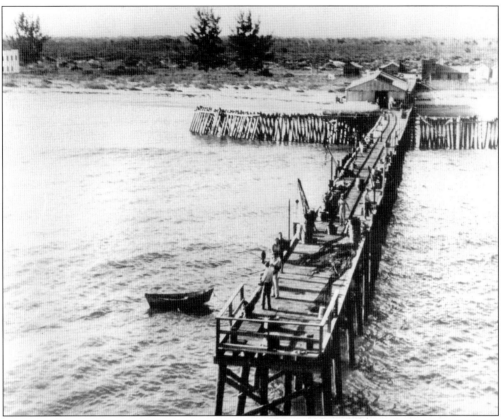

THE FIRST CANAVERAL PIER. The main purpose of the Canaveral Pier was to service the commercial fishing industry. A rail with a tram was used for hauling catch back to the shore for processing. To the extreme left can be seen the Harbor Inn. Once a year, the supply ship for the lighthouse would dock next to the pier and supplies would be offloaded. (Flossie Staton.)

MANTA RAY. The headlines of the *Cocoa Tribune* on July 27, 1933, read, "Ton and Half Devil Fish Landed from Ocean Last Sunday." The story told of Charles Williams, Copper Williams, Jimmie Pinkerton, and Lynn Turner bringing to Cocoa a ton and a half manta ray that was harpooned at Lancing Beach. The ray took them in their skiff for a ride in the ocean. "The beast measured sixteen feet and four inches across," reported the *Cocoa Tribune*.

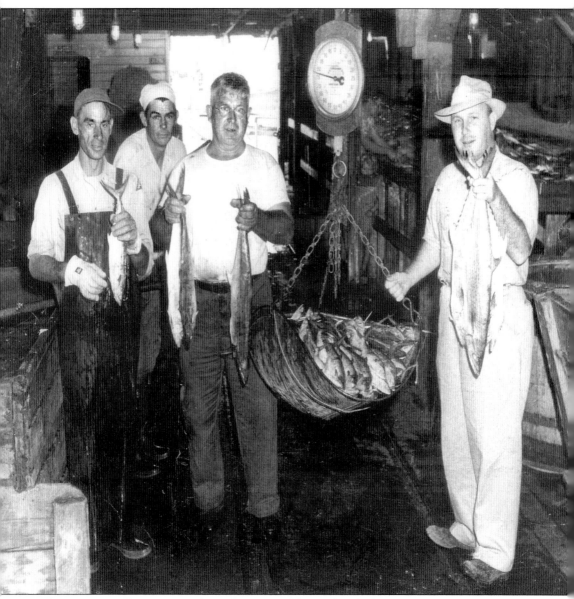

FISCHERS ARE FISHERMAN. Shown here are Eddie Fischer (right) and fish house workers. The activities of the Fischer family were often reported on in the *Cocoa Tribune* newspaper. On July 5, 1945, it reported that Sam Fischer (father of Eddie) of Fischer Seafoods, owner of the Canaveral Pier, said that the 800-foot pier damaged by the storm of October 1944 was being repaired that week and that it is hoped to have repairs and improvements completed within the next 90 days, barring bad weather. Fischer estimated that the repairs would cost between $10,000 and $12,000. Gordon Fortenberry, a well-known Merritt Island citizen who owned a sawmill, had been employed to do the work. (BHC.)

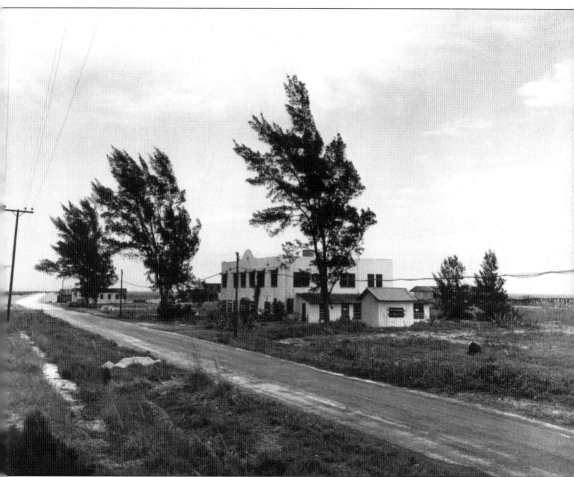

THE INN, THE IN PLACE TO BE. Canaveral Inn was built in 1926 near the pier. According to early oral histories, this stuccoed building had one of the only gasoline-powered generators on the cape. A system of streetlights stretching west along Pier Road was run by this generator. These were the only electric lights on the cape, and residents aptly named Pier Road "The Great White Way" or "The Million Dollar Highway." Early-20th-century newspapers would often report on the events at this inn. (Al Hartmann.)

GENERAL RANDOM INFORMATION: The hotel is not on the Dixie Highway and thus not subjected to fierce competition and short seasons. Again, while the majority of mainland or inland hotels are closed for the long summer season, the beach hotels enjoy business because the Floridian loves to go picnicking, fishing and bathing as does his northern cousin. Originally the hotel cost, furnished $20,000. The bar is not open now as the hotel is operated by two ladies, but the facilities are there. The beer and wine license is $50. per year; that for hard liquor around $1200. (These figures should be checked if the bar is of interest.) The tariff charged has usually been $3.00 to $4.00 per day American Plan, with slight concession by week or month. Twin-bedded rooms or those with a good view of the ocean command the higher rate, though all rooms are outside. Nearby points of interest include Praetorius' Tropical Gardens, an artists colony at Canaveral Beach Park and Canaveral Light. This last is of historical importance, being in use since before the Civil War.

Headquarters at the Inn has also proven practicable to the staid and quiet folks, and to the overworked business man who finds this retreat meets with the doctor's order when he says "take it easy." Not to be overlooked are the informality and cheeriness that only a small hostelry can offer, as it readily reflects the character and atmosphere created by its owner.

On occasional times when the hotel has been up for leasing there have always been applicants eager to take the place. This time, however, it is for sale, not lease, as the owner, 1200 miles away, is too occupied to continue to handle this small improved property. In the eleven years of its existence and continuous operation, the hotel has leased for a high of $200 per month and for a short time when the banks were closed, at a depression low of $25 per month. There is the full story. It is well to remember that the hotel was built three years after the Florida boom and has been operating in a sub-normal or depression period from the beginning. In spite of this a fair showing has been made as revealed by the above figures. This property is not offered as a get-rich-quick scheme, but only in the belief that the owner can make a comfortable and safe living, free from worries and heavy responsibilities such as large places so frequently labor under, with their usual burdensome if not crushing overhead. The taxes are negligible -- about $50 per year; quite a rare thing these days when so many places are tax ridden almost to the point of confiscation.

The Sale Price of the Hotel is $12,500; terms one-third down, balance to be amortized on a suitable basis with interest at 6%.

CONCLUSION: In the natural course of events when normal times return to this country, as they most certainly will sooner or later, the hotel should enjoy a much higher rate of return. However, if in defiance of history and precedent, conditions should not improve, an owner would still have an excellent defensive position as no better hedge can be found than an investment in a property like this. Everything in life is relative; for instance, $12,500 in the savings bank today will only buy an annual income of $250 to $300; surely not enough for one person to live on, let alone a family.

Whether the following applies to you personally, or not, is beside the point -- the pressure is there, nevertheless, during this temporary period where the law of diminishing returns is operating. Viz., today with many millions out of employment and many more millions eking out a bare uncertain existence, it is important to consider that the ownership of this hotel as yielding three things; first, a home; second, a job and a living; third, a nominal return on the investment. All three combined, which would be the case under Owner-Management, should offer someone a haven and security.

ANY FURTHER INFORMATION WILL BE GLADLY FURNISHED BY OWNER UPON REQUEST

OFFERED SUBJECT TO PRIOR SALE OR WITHDRAWAL WITHOUT NOTICE

Thomas L. Broughton
One Wall Street
New York, N. Y.

HARBOR INN SALES SHEET. From this sales letter for the Canaveral Harbor Inn, one can learn about the local area. Points of interest include Praetorius's Tropical Gardens, an artists' colony at Canaveral Beach Parl, and Canaveral Light, as well as the prices of real estate.

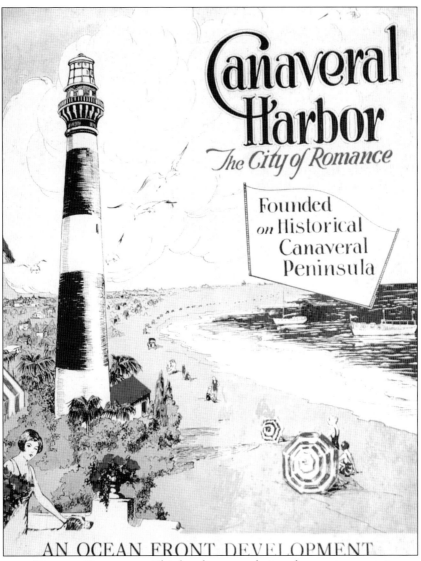

CANAVERAL HARBOR BROCHURE. This brochure was designed to get investors interested in a new community at Canaveral Harbor. In it, a comparison to Miami is made. The brochure reads "Miami of yesterday and Canaveral Harbor of today are easily compared and once compared it is hard to believe that Canaveral Harbor should take second place." In another section, the brochure writes about the proposed harbor and even a railroad from Orlando. "The commercial possibilities are also bright. The Harbor is there—waiting for the time when it should take its place as one of the leading seaports in the South. A charter has been granted for a railroad to serve it and open Central Florida to ocean transportation. It is obvious that the double opportunity for profits make it one of best of investment opportunities." It then mentions two other developments in the area. "On all sides of Canaveral Harbor extensive developments are with now under way or about to start. Desoto Beach is just to the north and if their present plans are carried through it will be one of the finest neighbors and will enhance the value of the property adjacent Journalista Beach, a project backed by newspapermen of the country is close by, as is Cocoa Beach where millions are to be spent." Unfortunately the crash of 1929 put a hamper on everyone's plans for development. (NBHM.)

DEVELOPER'S BIG DREAMS. R. B. Brossier, a local real estate developer and longtime Florida newspaperman, was active in real estate development in the 1920s, developing an area called Journalista. His twin brother, J. C. Brossier, was the editor of the *Orlando Evening Star*. The brothers were born in Key West in 1891. R. B. was a circulation manager for the *Miami Herald* and was very involved in the communities in which he lived. He was founder and charter member of the Orlando Jaycees, was a Rotarian, and was called a "100 percenter" by his fellow Rotarians. In Cape Canaveral, he funded and granted land for the local Volunteer Cape Canaveral Fire Department and had involvement with Port Canaveral. He and his son Dickson Brossier came in after World War II and developed several areas. A group of streets named after presidents are thought to be named by the Brossiers. (Orlando Jaycees.)

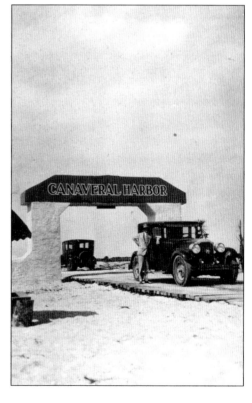

DREAMS THAT SLIP AWAY. At the beach, Canaveral Harbor had a sign and a boardwalk. The local newspaper often wrote of the great promise of this new community. (Nonie Fox.)

LIFE AT THE CAPE DURING WORLD WAR II. Sarah Davis was the daughter of the Coast Guard captain in charge of the lighthouse during the war, a Mr. Davis. There was plenty of World War II action at the lighthouse: residents would have to black out their windows and sometimes would go out to the beach to watch ships sinking from U-boat attacks. The lighthouse had to dim its light because the U-boat captains would use the beam of light to find the silhouette of Allied ships on the horizon for targets. (Nonie Fox.)

EARLY GERMAN AMERICAN SETTLERS. Pictured are Otto and Elizabeth Eberwein. Otto was Elizabeth's brother-in-law. Elizabeth Eberwein was born February 27, 1867, in Mannheim, Germany, and served as postmaster for Artesia Post Office. Oral histories indicate Elizabeth used to cook up some delicious pancakes. (Flossie Staton.)

WINTER VISITORS. Winter visitors have always been common to the area. John (left) and Elizabeth Eberwein are shown with winter visitor Howard Snyder from Michigan. The Eberweins had many relatives and connections from Michigan and would often entertain visitors from there. (Flossie Staton.)

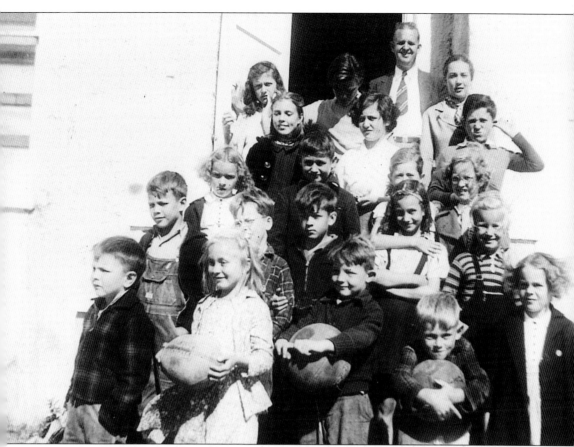

CAPE CANAVERAL SCHOOL, 1938. Students and their teacher pose for a picture. From left to right are (first row) Jessie Hill, Donna Jandreau, Lee Chamberlein, Freddie Jandreau, and Patsy Evans; (second row) Ira Hill, Roger Dobson, Benjie Lewis, Delores Morgan, and Florence Holmes; (third row) Dorita Evans, Melvin Tucker, Gloria Whidden, and Beverly Dobson; (fourth row) Noni Knutson, Kathryn Morgan (Mask), and Tommy Willis; (fifth row) Lillie Jane Lewis, Jack Mask, and Betty Mae Jeffords; (six row) G. C. Evans. The teacher, G. C. Evans, was well thought of by his students; he was regarded as a tough disciplinarian but taught his students well. (Florida Historical Society.)

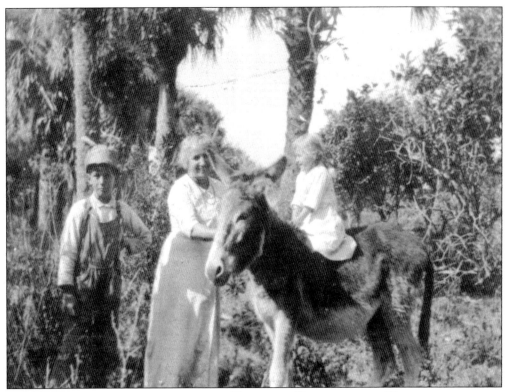

ELIZABETH EBERWEIN WITH DONKEY AND DAUGHTER ELIZABETH. Elizabeth and her husband, John, reared six children in Artesia. Three of her sons died while serving in the U.S. Army during 1917 and 1918. Elizabeth, as a mother who lost children in the Great War, was honored with a gold star. (Flossie Staton.)

SAM KNUTSON—A GOOD BUSINESSMAN. Sam Knutson was originally from Minnesota. His parents emigrated there from Norway. Sam moved to Florida and taught school in the one-room schoolhouse at Artesia around 1916–1917. He lived with Bernice and Wyatt Chandler, where he met their daughter, Lorena, who was also his student. He married Lorena when she turned 18, and in 1920, they moved to Cocoa, where Sam owned a bicycle shop, shoe shop, and taxi stand. After the stock market crash of 1929, they moved back to Artesia and built a home, which still remains at the time of this writing. The house was of stucco (distinguishing it from others on the cape, which were of unpainted wood) and had indoor plumbing. Sam was also a real estate broker, was very active in bringing about the development of Cape Canaveral, and served as a harbor commissioner. (Nonie Fox.)

HELEN CHANDLER. Helen Chandler, a local resident of the Artesia/Cape Canaveral area, was a registered nurse at Wuestoff Hospital. She gave several recorded oral histories telling about how life was in this local area; these are on file at the BHC. Helen was the mother of Roger Dobson (below). (Nonie Fox.)

LOCAL BOY DOES GOOD. Roger Dobson is shown here in high school. Roger's lists of accomplishments include cofounding the accounting firm Hoyman, Dobson, and Company in 1964 and serving as president of the Cocoa Beach Chamber of Commerce; on the Cape Canaveral Hospital Board of Trustees; and on the Brevard Community College Board of Trustees. He was a county commissioner and a partner in several hotels in Cocoa Beach and Cape Canaveral. (Nonie Fox.)

It's My Birthday. The local newspaper *Cocoa Tribune* reported, "Miss Nona Lee Knutson entertained a group of little folks with a party on her sixth birthday last Thursday. Games were played and wiener roast, ice cream and cake were enjoyed by the children." (Nonie Fox.)

Florence Holmes, Aged Six and a Half Months. Florence Holmes won a case of Carnation milk for entry of this photograph into the Healthy Baby contest. She provided many images for this chapter in this book; she also shared stories for an oral history of the area, such as the "gopher hole" incident. Flo said, "My mother and Nonie's mother were very good friends and despite the difference in our ages the children played together (they were 5 and 6 years older), though I was somewhat of an anchor to have to drag around at times, particularly when we were playing in the fields between Nonie's house and Wyatt and Bernice Chandler's place. I must have been being a pest one day and there was a huge gopher hole in the field so as we passed it they gathered me up and shoved me down into it, not far and more to scare-straight than to harm, but after I grew up and realized that very often rattlesnakes took shelter in gopher holes I felt fortunate that none were home that day!" (Flossie Staton.)

FLOSSIE AND HER MOM: WILD PEAFOWL IN CAPE CANAVERAL. Anybody living in the city of Cape Canaveral can tell about the wild peafowl. Here is the story why they are there. Flossie Staton said, "My Mom (Elizabeth Eberwein) had grown up with only brothers, so she was a tomboy and much more interested in doing outside things, than in. She decided to raise chickens after my college roommates gave me two Easter chicks and I had to bring them home (on the Greyhound bus) during the Easter holiday of 1951. They grew up to be nice chickens, so she bought more and built a big pen and a chicken house. After that, it was just a short step to a clutch of peafowl eggs, which she bought from someone and persuaded one of the Bantam hens to hatch. That was quite a sight as they grew to be so much bigger than their 'mother' and followed her around everywhere. She was a persistent 'sitter' and sat for several more little broods, but eventually it got to be too much for her, all these huge 'kids' who followed her everywhere, expecting her to help them find food and she began to shun them and find refuge in an oak tree. Mama says she never was 'right' after that. But anyway, that was the beginning of the peafowl over here, though it wasn't until she gave my Uncle William (Eberwein) a pair that things actually got out of hand as he was not so diligent in keeping them penned as Mama was and eventually they began raising broods in the woods and those babies that escaped the foxes and coons and possums started ranging farther and farther a field, finding nesting places of their own. So Bill Eberwein was actually responsible for the proliferation of the peafowl population on the beach." (Flossie Staton.)

COLD ONE IN CENTRAL FLORIDA. Ben Abbott (left) enjoys a cold beer with visitor Julian Blanchard. Ben was a commercial fisherman and colorful character. Oral history reveals folklore that he would bury cans of beans at different locations because he said, "one never knew where one find themselves hungry." (Joni Mitchell.)

PHILIP EBERWEIN. Another commercial fisherman, Philip Eberwein also volunteered as a policeman for Cape Canaveral. (Flossie Staton.)

Four

GROUND CONTROL TO COLONEL JOHN
THE RACE FOR SPACE BEGINS

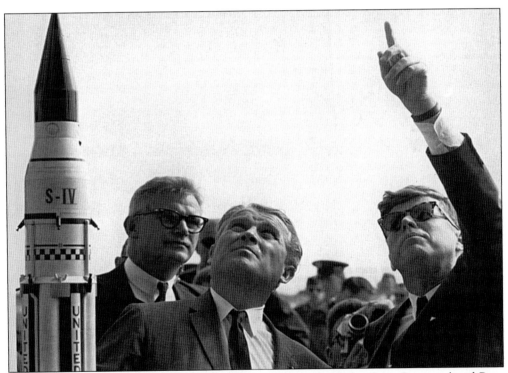

THE RACE FOR SPACE. The early history of the space race includes Cape Canaveral and Pres. John F. Kennedy's visit to NASA on November 16, 1963. Dr. Wernher von Braun explains the Saturn launch system to Pres. John F. Kennedy. NASA deputy administrator Robert Seamans is to the left of Von Braun. One of the most popular pictures of the space era, this symbolizes America's race for space, John F Kennedy's immortal speech, and his challenge to have a man on the moon by the end of the decade. (NASA at KSC.)

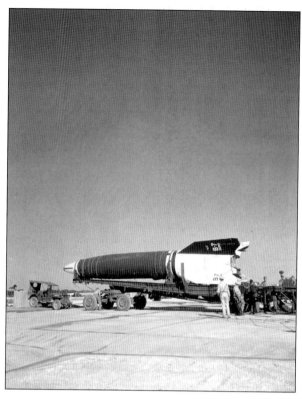

BUMPER ROCKET. The bumper rocket was derived from the German V-2 rocket and designed to test horizontal staging; it was one of the first multistage rockets. At White Sands Proving Grounds on May 15, 1948, the rocket reached an altitude of 79.1 miles. On February 24, 1949, Bumper 5 reached a then-record altitude of 400 kilometers (250 miles) and a velocity of 8,290 kilometers per hour (5,150 miles per hour). It carried a payload that measured atmospheric temperature. Its previous successful launches from White Sands in New Mexico were followed by launches from Cape Canaveral. (Al Hartmann.)

BUMPER SITTING ON THE PAD. The bumper was a true hybrid in that the multiple stages were made up of a U.S. Army missile (top) and German V-2 missile (bottom). The platforms on top the scaffolding allowed workers to install and check out the WAC (Without Attitude Control) corporal upper stage atop the German V-2 missile. In 1950, two bumper launches were made from launch complex 3 at Cape Canaveral, Florida. Due to technical issues, Bumper 8 was launched on July 24, before Bumper 7, which was launched on July 29. These missions marked the first and second launches from Cape Canaveral's young missile test grounds. (Al Hartmann.)

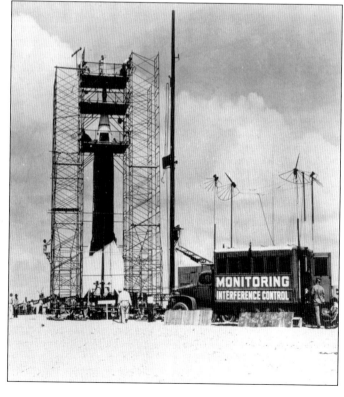

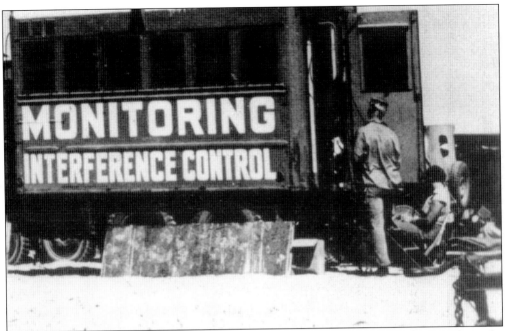

PREPARING A BUMPER ROCKET FOR LAUNCH. In the far right corner of the photograph can be seen Elizabeth Carlton Bain, who was transferred to the Joint Long Range Proving Ground in 1949. Her work was in personnel recruiting and training, but due to a shortage of personnel needed to launch the Bumper 7 and 8 missiles, she went into service to monitor radio interference. Her post was close but a safe distance away from the Bumper missile. In the early days at the Space Center, the budding space industry showed equality in equal opportunity. Here an unidentified African American male is entering a doorway to the Monitoring Interference Control center. The first female space worker can be seen to the right handling instrumentation.

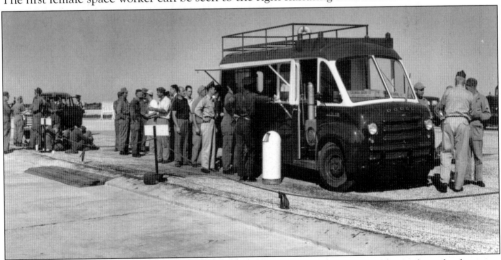

HUNGRY WORK LAUNCHING ROCKETS. Life was spartan and, for personnel at the bumper launches, in many cases primitive. The majority of army personnel were housed in tents where they were at the mercy of the elements, including extreme heat and humidity. There were clouds of mosquitoes, and one would have to beware of the large quantities of rattlesnakes and alligators. Here workers are lined up at the lunch wagon at Pad 3 in 1951. (Al Hartmann.)

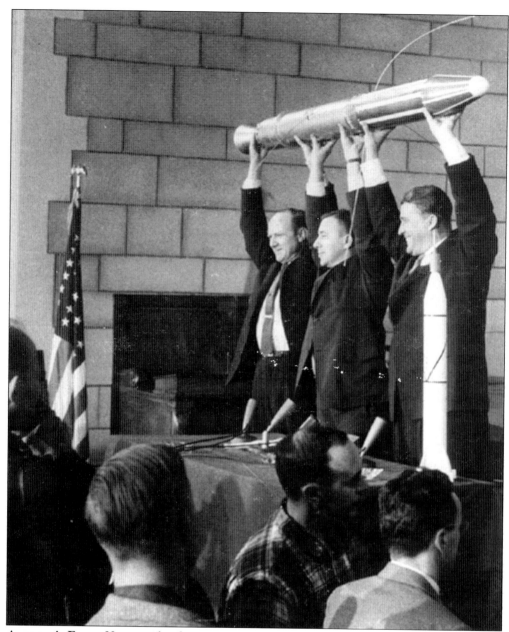

AMERICA'S FIRST. Here are the three men responsible for the success of *Explorer 1*, America's first Earth satellite, which was launched January 31, 1958. At left is Dr. William H. Pickering, director of the Jet Propulsion Laboratory (JPL), which built and operated the satellite. Dr. James Van Allen (center), of the State University of Iowa, designed and built the instrument on *Explorer* that discovered the radiation belts that circle the Earth. At right is Dr. Wernher von Braun, leader of the army's Redstone Arsenal team, which built the first stage Redstone rocket that launched *Explorer 1* on January 31, 1958. (NASA archives at NIX.)

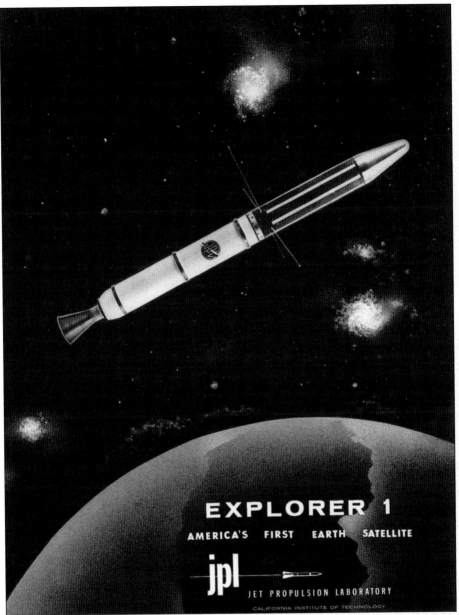

EXPLORER 1

AMERICA'S FIRST EARTH SATELLITE

jpl

JET PROPULSION LABORATORY

CALIFORNIA INSTITUTE OF TECHNOLOGY

A LIFT TO THE COUNTRY. *Explorer 1* was the first satellite launched into orbit by the United States, just four months after the Soviet Union's *Sputnik 1*, lifting the nation's morale by joining the space race. The satellite's primary purpose was to use a cosmic ray detector to measure the radiation environment in Earth's orbit. The experiment was engineered by Dr. James Van Allen of the State University of Iowa, and after discovery, these radiation belts became known as the Van Allen Belts in his honor. The actual satellite was designed and built by the Jet Propulsion Laboratory in less than three months. The *Juno 1* rocket that lifted the satellite into orbit was developed under the direction of Dr. Wernher von Braun. *Juno 1* was built in four stages: the first stage was a modified Redstone (lengthened to hold more fuel); the second stage a cluster of 11 Baby Sargent solid fuel rockets; the third stage a cluster of three Baby Sargent solid fuel rockets; and a single Baby Sargent was part of the satellite as a fourth stage. (NASA archives at NIX.)

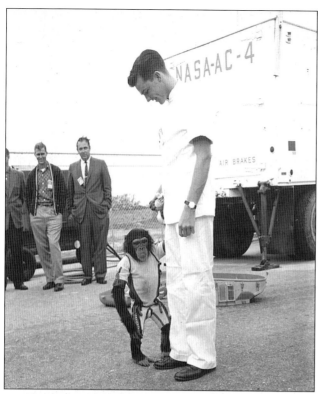

ASTROCHIMP, THE FIRST HOMINID IN SPACE. Ham, the first chimpanzee ever to ride into space, is shown off by his animal trainer at Cape Canaveral, Florida. Ham the Astrochimp was the first hominid launched into outer space. His name, Ham, is an acronym for the Holloman Aerospace Medical Center in New Mexico. On January 31, 1961, Ham was secured in a Project Mercury capsule and launched from Cape Canaveral into outer space. The capsule suffered a partial loss of pressure during the flight, but Ham's spacesuit prevented him from suffering any harm. Ham's lever-pushing performance in space was only a fraction of a second slower than on Earth, demonstrating that tasks could be performed in space. (NASA at KSC.)

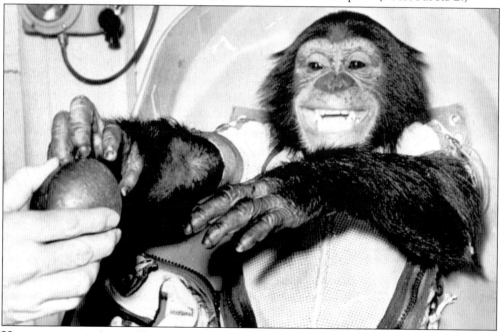

HUNGRY FOR AN APPLE. Ham reaches for an apple, his first food from his space flight. When the capsule was opened to recover Ham, it was reported he was snarling and tried to bite the photographers. Ham enjoyed celebrity status in his retirement and lived to the ripe old ape age of 24 years old. (NASA at KSC.)

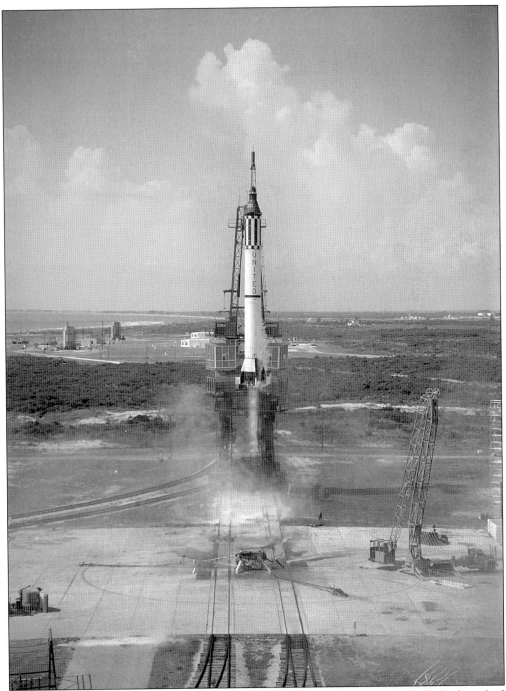

LAUNCH OF FREEDOM 7. *Freedom 7*, the first American-manned suborbital space flight, launched from Pad 5 by a Mercury-Redstone (MR-3) rocket. Aboard was astronaut Alan Shepard, who was the second person and the first American in space. He later commanded the *Apollo 14* mission and was the fifth person to walk on the moon. He was also the first and only astronaut to golf on the moon. Oral history indicates he exaggerated the claim by stating that he hit the ball and it went for "miles and miles and miles." (NASA at KSC.)

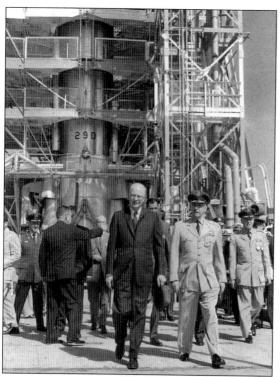

THE FIRST PRESIDENT TO VISIT. President Eisenhower visited on February 10, 1960. NASA got its start under President Eisenhower's administration. On July 29, 1958, the president signed the National Aeronautics and Space Act, which created NASA. The following year, on April 9, 1959, seven men were selected to become Project Mercury astronauts: John Glenn Jr., Scott Carpenter, Leroy Gordon Cooper, Virgil "Gus" Grissom, Walter Schirra Jr., Alan Shepard Jr., and Donald "Deke" Slayton. (45th Space Wing History Office.)

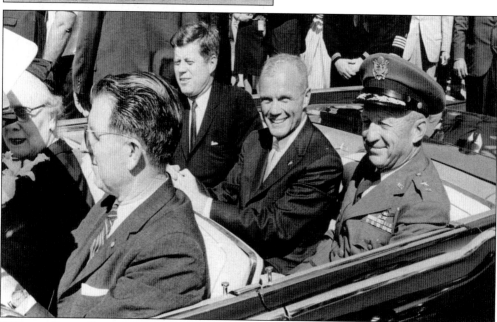

JFK AND JOHN GLENN IN THEIR HISTORIC PARADE. In the backseat from left to right, Pres. John F. Kennedy, John Glenn, and Gen. Leighton I. Davis ride together during a parade in Cape Canaveral, Florida, after Glenn's historic first U.S. human orbital space flight. Newspapers reported over 100,000 people gathered along A1A on the route of John Glenn's parade. Although this parade started at Patrick Air Force Base and traveled through Cocoa Beach, President Kennedy did not join the parade until it was at the cape. (NASA at KSC.)

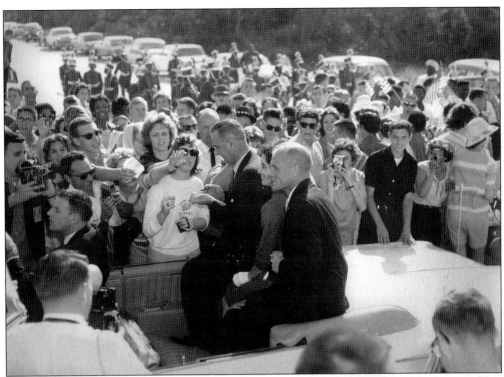

PROFILES IN COURAGE. Vice Pres. Lyndon Baines Johnson was in the first part of the parade that rode from Patrick Air Force Base through Cocoa Beach to Cape Canaveral. At the cape, President Kennedy joined the party for photographs. Pres. John F. Kennedy, astronaut John Glenn, NASA officials, VIPs, and others take part in welcome ceremonies at Cape Canaveral in honor of Glenn's successful orbital mission on February 23, 1962, in front of Hanger S. (NASA at KSC.)

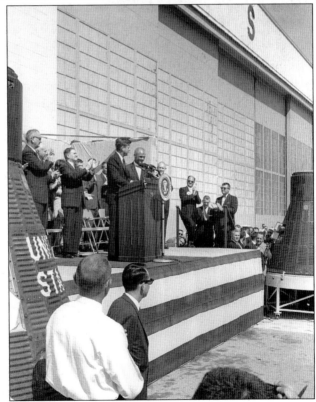

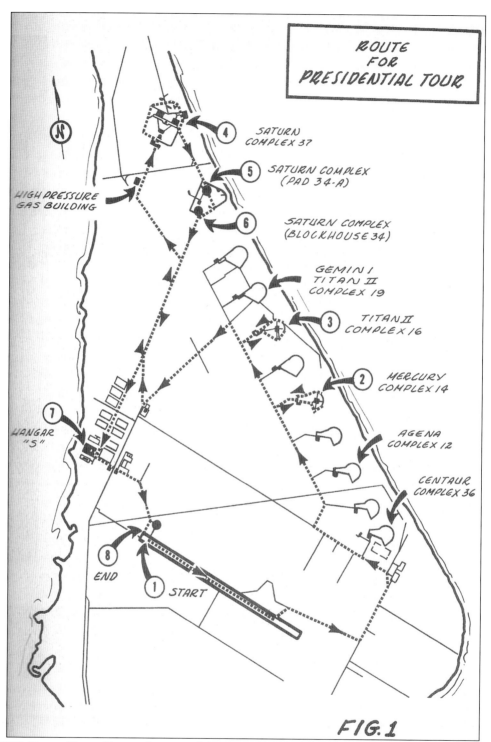

ROUTE FOR PRESIDENTIAL TOUR

FIG. 1

JFK's Final Visit. Here is the map of the route for Pres. John F Kennedy at Cape Canaveral on November 16, 1963. This visit was just six days before he was assassinated in Dallas, Texas. (45th Space Wing History Office.)

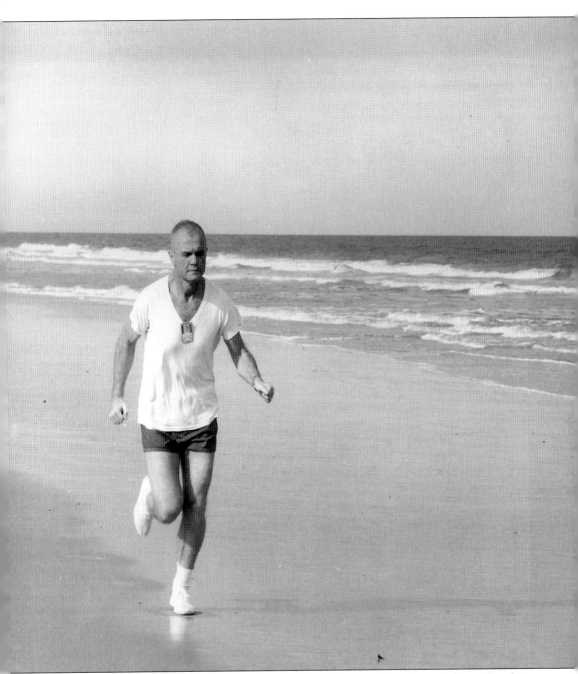

LEAVING FOOTPRINTS. John Glenn jogs on the Cape Canaveral seashore. Glenn stayed in seclusion at an undisclosed Cape Canaveral residence prior to his journey into space. He would often be seen jogging on the Cape Canaveral seashore. *Life* magazine showed some pictures of John Glenn relaxing with his family at his temporary Cape Canaveral lodging. (NASA photograph; U.S. Space Walk of Fame.)

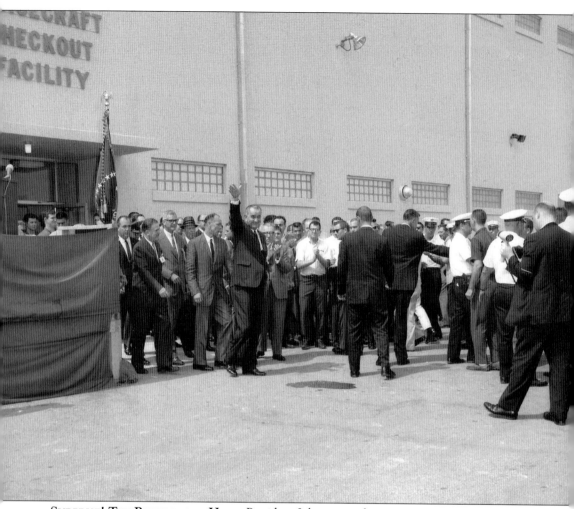

SURPRISE! THE PRESIDENT IS HERE. President Johnson made a surprise visit to Cape Kennedy on September 15, 1964, to take a firsthand look at the U.S. space program. The president was accompanied on his tour by Maj. Gen. Vincent G. Huston, commander of the Air Force Eastern Test Range (left), and James Webb, administrator of NASA. This was the president's first visit to the cape since he was sworn into office in November 1963 and his fourth visit in the previous three and a half years. (Air Force Space and Missile Museum Library.)

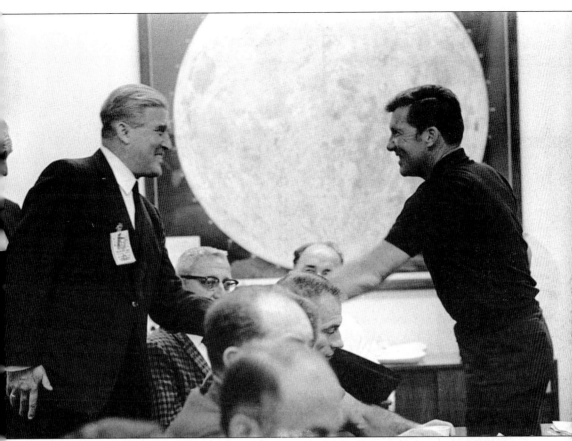

Two Space Giants Meet. *Apollo 7* commander Walter M. Schirra Jr. (right) greets Dr. Wernher Von Braun, director of the Marshall Space Flight Center. At far left can be seen Dr. Kurt Debus, Kennedy Space Center director, during a pre-launch mission briefing held at the Florida Spaceport on October 10, 1968. Father of the Space Industry Wernher von Braun is considered the greatest rocket scientist in history. His crowning achievement, as head of NASA's Marshall Space Flight Center, was to lead the development of the *Saturn V* booster rocket that helped land the first men on the moon in July 1969. Von Braun, a German involved in V2 rocket development in Peenemunde, was also responsible for engineering the surrender of 500 of his top rocket scientists, along with plans and test vehicles, to the Americans at the close of World War II. (NASA at KSC.)

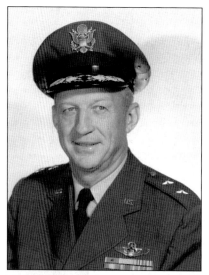

GENERAL'S ORDERS. Teamwork pays off. Maj. Gen. Leighton Davis was a key team player to the expansion of NASA in the space race. For his efforts, he was awarded the National Aeronautics and Space Administration Medal for Outstanding Leadership from the president of the United States on May 20, 1963. He was decorated with the Distinguished Service Medal and the Legion of Merit with oak leaf cluster. Major General Davis worked closely with Kurt Debus during the expansion of the Apollo program. Dr. Kurt Debus and Maj. Gen. Leighton Davis, U.S. Air Force, worked closely at the cape expanding the space program. Together they chose Merritt Island over a number of other locations as their site selection. NASA acquisitions included some 84,000 acres of sand and scrub plus 56,000 additional acres of submerged lands, at a total cost of $71,872,000. (NASA at KSC.)

BUZZ ALDRIN "SAVING THE SPACE PROGRAM." Aldrin examines the Astronaut Maneuvering Unit. Highly trained, innovative, and motivated, Buzz came through and delivered when the space agency needed it the most. Aldrin was selected as part of the third group of NASA astronauts in October 1963. After the deaths of the original *Gemini 9* prime crew, Aldrin was promoted to backup crew for the mission. The main objective of the revised mission (*Gemini 9A*) was to rendezvous and dock with a target vehicle, but when this failed, Aldrin improvised an effective exercise for the craft to rendezvous with a coordinate in space. He was confirmed as pilot on *Gemini 12*, the last Gemini mission and the last chance to prove methods for extravehicular activity. He utilized revolutionary techniques during training for that mission, including neutrally buoyant underwater training. Such techniques are still used today. Deke Slayton credited Aldrin with "saving the space program" because of these techniques. Buzz Aldrin, Sc.D (born January 20, 1930, as Edwin Eugene Aldrin Jr.), an American pilot and astronaut, was the lunar module pilot on *Apollo 11*, the first lunar landing. He became the second person to set foot on the moon (after mission commander Neil Armstrong). (NASA photograph; Joe Morgan.)

INTERNATIONAL INVOLVEMENT.
Pan Am Worldwide Services
employee John "Jack" Galt performs
an experiment for NASA in South
Africa. The object was to see if a
bright light generated by a device on
Earth could be seen by astronauts
in an orbiting space capsule. The
second experiment was a success
with astronaut Gordan Cooper
in May 1963. The South African
newspaper the *Friend* headlined a
story called "Spaceman Sees City
Light." It continued, "Mercury
Control reported early this
morning that Cooper in his Faith
7 spacecraft had seen the ground
burning light from Bloemfontein.
The special light burned for three
minutes and is the only kind in the
world." The newspaper also reported
that it was known that Cooper had
brought some fishing tackle with
him on his space trip in the event
he had to wait awhile for ocean
recovery. (Gail Galt.)

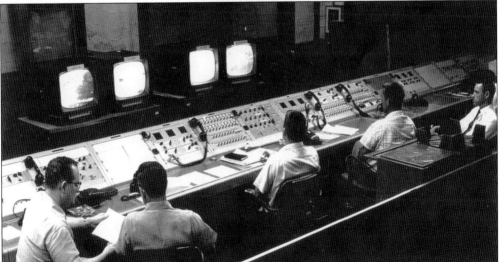

BOB BORDERS. Bob Borders (far right) arrived in Cape Canaveral in 1955 with Pan American
World Airways. This company had been hired to turn the Florida scrub brush into America's
first missile and rocket base. The U.S. Air Force chose Pan Am as the prime base operations
and maintenance contractor for the 10,000-mile-long Florida Missile Range that stretched all
the way to the Indian Ocean. With the outbreak of the Cuban Missile Crisis in 1962, Bob and
his team got involved in making the missile base into an air station and lighting the skid strip
into a proper runway. Bob Borders career spanned 50 years from Pan Am to Johnson Controls to
finally IAP Worldwide Services, where he retired in 2005. (Joan Borders.)

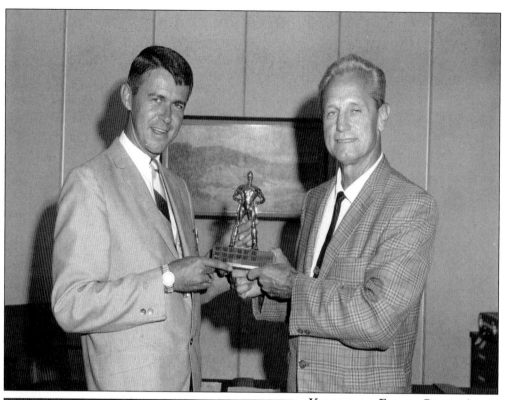

KEEPING AN EYE ON COSTS. A Mr. Ford presents the "Trim and Cost" award to R. W. Phillips at the MSO (Manned Space Operations) building on September 6, 1966. (NASA photograph; Joe Morgan.)

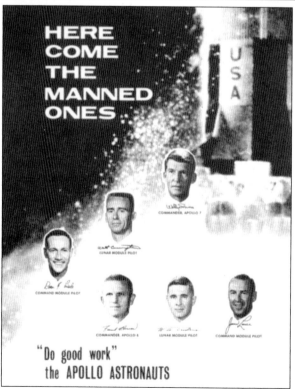

KEEPING AN EYE ON QUALITY. This poster reminds space workers to keep quality high as the Apollo project would be launching the new set of astronauts. (NASA photograph; Joe Morgan.)

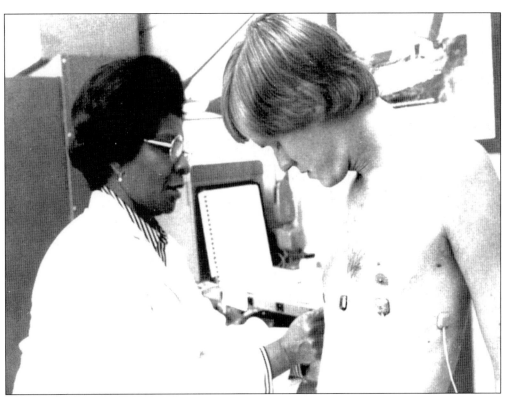

KEEPING AN EYE ON HEALTH.
Health aide Eunice Allen attached
electrodes to Paul Kjos in preparation
for a stress test. She had the word
whether they went or not. All the
cape workers knew her as "Mom."
(NASA at KSC.)

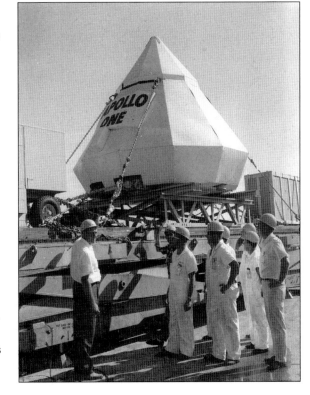

"HERE COMES APOLLO!" The
Apollo Command module is under
wraps to be mated with the new up-
rated *Saturn I* vehicle 204. It arrived
via the "Pregnant Guppy," a specially
designed wide-bodied aircraft used
for ferrying NASA components. This
picture was taken August 26, 1966.
(NASA photograph; Joe Morgan.)

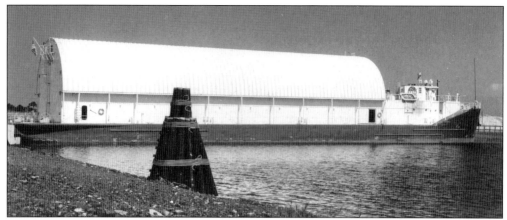

ARRIVING AT LAUNCH COMPLEX 39, *PROMISE* TRANSPORTING THE PARTS. A barge called the *Promise* was built by Chrysler. It featured eight H-1 engines built by Rocketdyne. During the Apollo project, it would carry the first stage and engines of the *Saturn V* rocket. Shipment of the oversize stages between Huntsville, Michoud, the Mississippi test facility, the two California contractors, and the Kennedy Space Center in Florida required barges and seagoing ships. Soon Marshall Space Flight Center in Huntsville, Alabama, found itself running a small fleet that included the barges *Palaemon, Orion,* and *Promise.* For shipments through the Panama Canal, the USNS *Point Barrow* and the SS *Steel Executive* were used. For rapid transport, there were two converted Stratocruisers (airliners) available, the "Pregnant Guppy" and "Super Guppy." Their bulbous bodies could accommodate cargo up to the size of an S-IVB stage. (NASA photograph; Joe Morgan.)

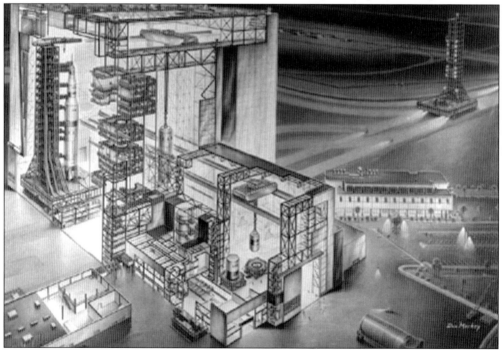

MACKAY ILLUSTRATION OF THE VEHICLE ASSEMBLY BUILDING. The largest building in the world is located at Area 39. NASA illustrator Don Mackay also designed some artistic greeting cards showing animated UFOs and aliens greeting astronauts. (NASA photograph; U.S. Space Walk of Fame.)

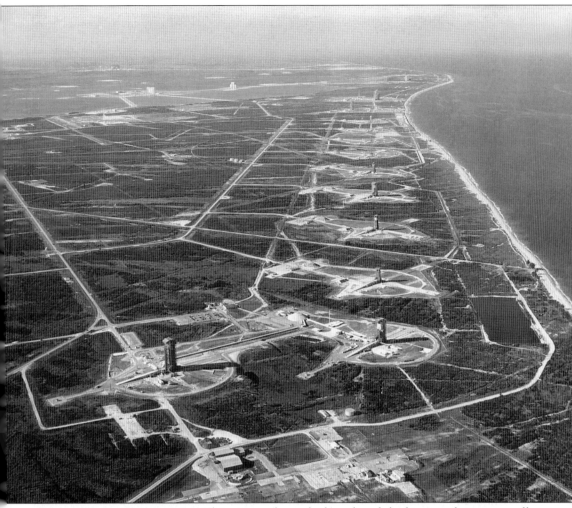

AERIAL VIEW OF MISSILE ROW. This picture shows the launch pads looking north in an overall aerial view of Missile Row, Cape Canaveral Air Force Station. In the upper left-hand corner can be seen the Vehicle Assembly Building (VAB) under construction. (NASA at KSC.)

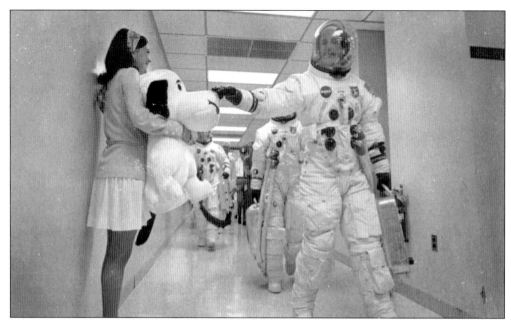

SNOOPY BECOMES A MASCOT. Charles Shultz's creation Snoopy became a space industry icon not only as a mascot but also a prestigious award known as the "Silver Snoopy Award" for excellence in quality assurance. Here *Apollo 10* commander Thomas P. Stafford pats the nose of Snoopy, mission mascot, held by Jamey Flowers, astronaut Gordon Cooper's secretary, as the crew walks along the hallway to the transfer van for a trip to Launch Complex 39B. (NASA at KSC.)

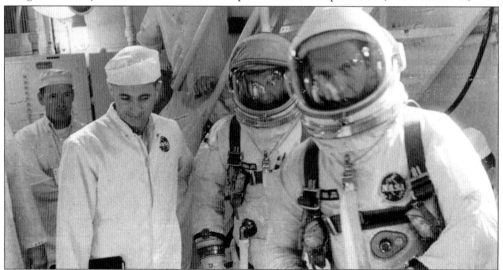

MAKING THEIR MARK IN HISTORY. Astronauts Conrad and Cooper are seen during a simultaneous launch demonstration at Pad 19. Astronaut Charles "Pete" Conrad was a veteran of four space flights and the third man to walk on the moon. He was killed in a motorcycle crash while riding his Harley Davidson at the age of 69 on July 8, 1999. Conrad had a lot of charisma in the public eye, and he was very popular among his fellow astronauts. His funeral service also marked one of the largest gatherings of astronauts in history. Gordon "Gordo" Cooper has a unique history in that he is the only astronaut to give an account of a UFO (Unidentified Flying Object). (NASA photograph; Joe Morgan.)

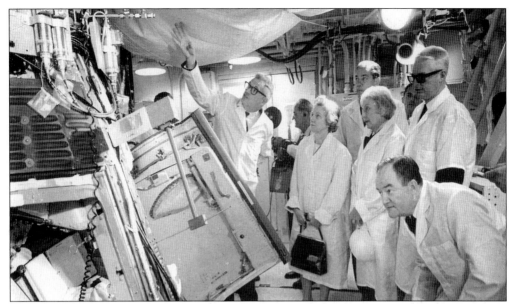

A WISE INVESTMENT. Vice Pres. Hubert Humphrey, shown here on November 20, 1968, called the Apollo Project a wise investment. Humphrey and his wife, Muries, stopped off at the Kennedy Space Center on their way from a post-election vacation in Miami Beach. "What you've really done," he told workers, "is given the American people a lift." He showered praise, handshakes, and smiles everywhere he went. (45th Space Wing History Office.)

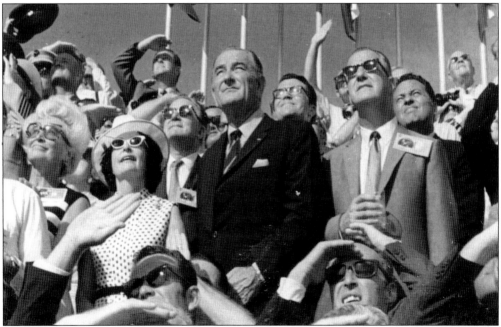

FAMILIAR FACES. Vice Pres. Spiro Agnew (right, with glasses) and former president Lyndon B. Johnson (center) view the liftoff of *Apollo 11* from Pad 39A at Kennedy Space Center at 9:32 a.m. on July 16, 1969. Lady Bird Johnson can be seen accompanying Lyndon Johnson. *Apollo 11* was the first manned mission to the moon; it carried Neil Armstrong, Michael Collins, and Edwin "Buzz" Aldrin. It was boosted into space by a *Saturn V* rocket. (NASA at KSC.)

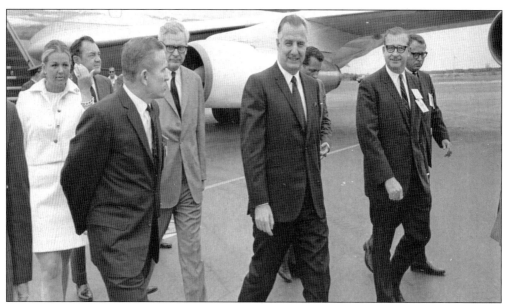

HE'S A BELIEVER NOW. Vice Pres. Spiro Agnew (center) said, "I'm a believer now." The vice president was as thrilled as a kid watching his first space shot and left the moon port a believer. "I'm going to do my best to nudge the President [Nixon] into awareness of what I consider the overriding importance [of the Space program]," he told a sparse wet crowd at the Skid Strip prior to jetting back to Washington. Agnew can be seen speaking to Frank Borman (left foreground) on March 4, 1969. (45th Space Wing History Office.)

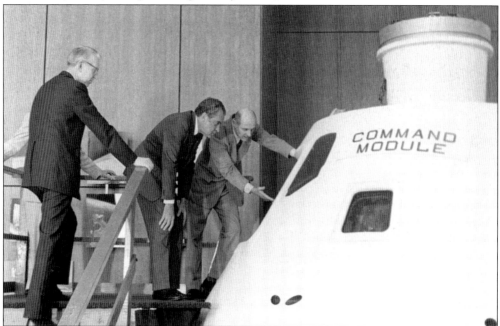

NIXON AT THE CAPE. Pres. Richard M. Nixon is given a briefing on the Apollo Command Module, similar to the one that was used in the 1975 joint U.S./U.S.S.R. *Apollo-Soyuz* test flight. Conducting the tour is the American commander for the flight, astronaut Thomas P. Stafford. Standing at the president's right is Dr. James C. Fletcher, NASA administrator. (NASA at KSC.)

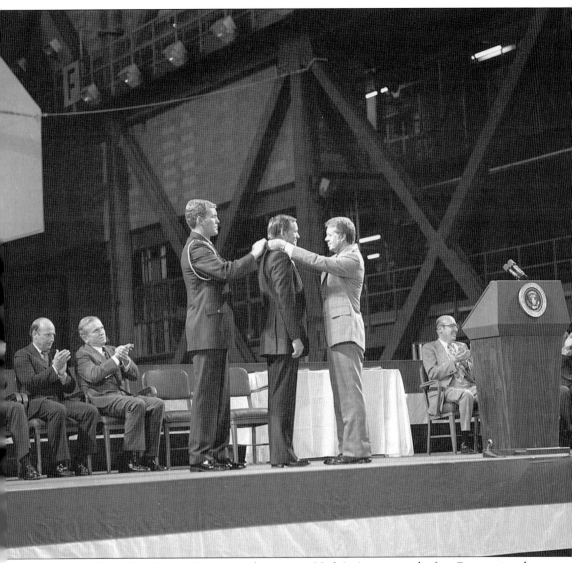

ONE GIANT LEAP. Pres. Jimmy Carter awards astronaut Neil A. Armstrong the first Congressional Space Medal of Honor. He is assisted by Capt. Robert Peterson. Armstrong, one of six astronauts to be presented the medal during ceremonies held in the Vehicle Assembly Building (VAB), was awarded for his performance during the *Gemini 8* mission and the *Apollo 11* mission, when he became the first human to set foot upon the moon. (NASA at KSC.)

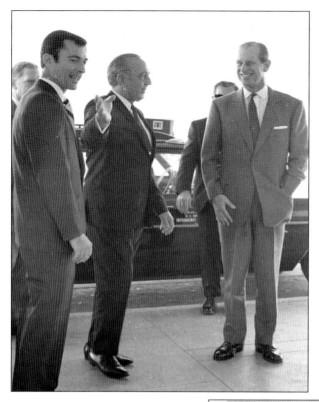

A PRINCELY VISIT. From left to right, astronaut John Young, Dr. Kurt H. Debus, and Maj. Gen. David M. Jones all briefed Prince Phillip of the United Kingdom on the royal visit on February 14, 1970. Dr. Debus was director of the John F. Kennedy Space Center, NASA, from its inception in 1962 to the space shuttle era in 1974. He was born in Frankfurt, Germany, in 1908. He was inducted with other German rocket scientists, including Wernher Von Braun, from the rocket center in Peenemunde, Germany, in 1945 to the United States. He participated in the missile systems development program of the army and in upper atmospheric research in Fort Bliss, Texas, and White Sands, New Mexico. Later he supervised development and construction of launch facilities at Cape Canaveral for Redstone, Jupiter C, Juno, and Pershing missiles. (NASA at KSC.)

"SIGN HIM UP!" With the help of astronaut John Young, the prince commanded a lunar module simulator to a pinpoint landing. "He's a good pilot," astronaut Young said. "We ought to sign him up." The prince was more modest. "I think it flew under its own volition," he said, refusing to take credit. (NASA at KSC.)

MAROONED. Maj. Gen. David M. Jones (center) poses with actor Gregory Peck (left) and director John Sturges during filming of the motion picture *Marooned* at Cape Kennedy. Over the years, the space center has frequently been visited by many actors and entertainers; including Jack Benny, John Wayne, Don Knotts, Michael York, and Barbara Eden. (45th Space Wing History Office.)

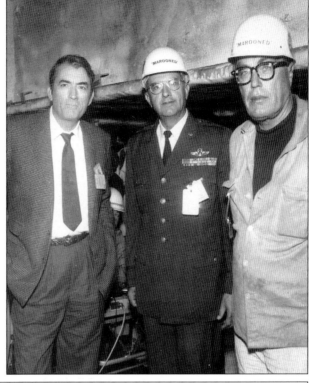

RESCUE VEHICLE USED IN MAROONED. *Marooned* debuted only months after the moon landing of *Apollo 11*. However, it also debuted six months before the ill-fated *Apollo 13* mission. (45th Space Wing History Office.)

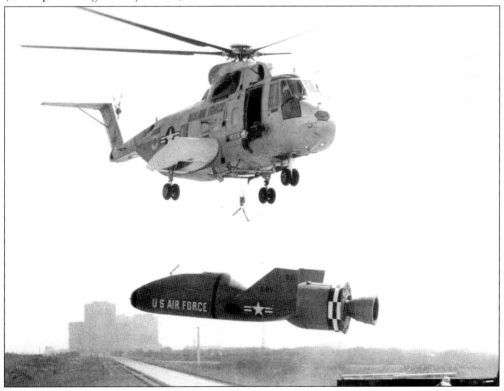

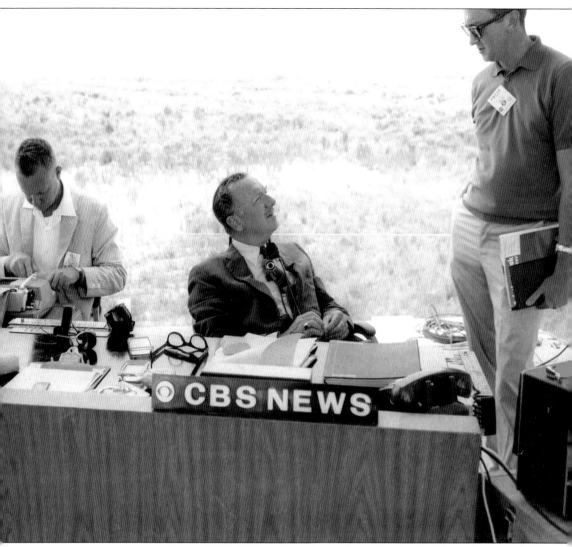

ANCHORMAN AT THE CAPE. CBS's Walter Cronkite anchors the *Apollo* 8 launch coverage at KSC on December 21, 1968. He was probably one of the most enthusiastic reporters of the space race; when Neil Armstrong walked on the moon, he was rendered speechless with awe. Local oral histories report that he would interview astronauts over a cup of coffee at the Moon Hut in Cape Canaveral for a relaxed setting. (45th Space Wing History Office.)

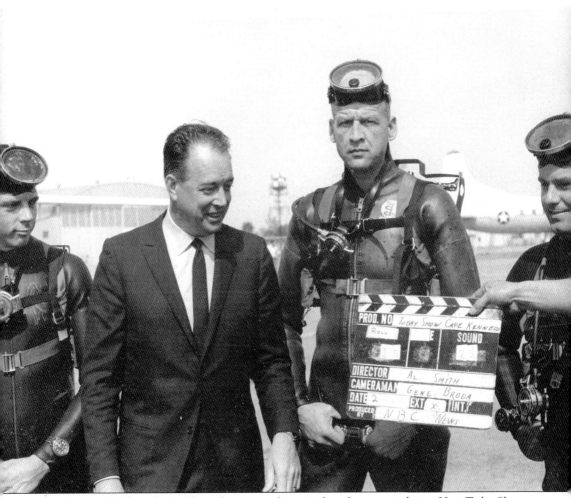

TODAY SHOW. NBC broadcasted from the cape and reported on the space industry. Here *Today Show* host Hugh Downs is photographed with a frogman used in astronaut training. Also on the show were Jack Lescoulie and newsreader Frank Blair anchoring the broadcasts. Hugh Downs started his career at NBC as a sidekick to Jack Parr and was later on the *Today Show*. He is better known as a long-term anchor at ABC's *20/20* with Barbara Walters. (45th Space Wing History Office.)

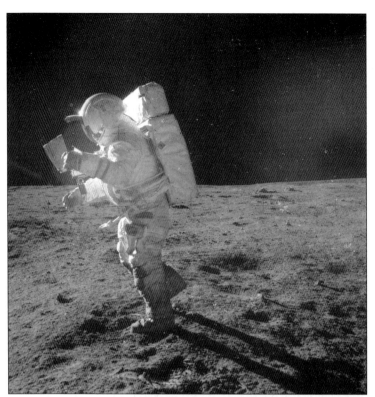

MOONWALK MITCHELL STYLE. Astronaut Edgar D. Mitchell, *Apollo 14* lunar module pilot, moves across the lunar surface as he looks over a traverse map during extravehicular activity (EVA). On the way back to Earth, Mitchell performed an unofficial ESP test using playing cards with a select group of people back at Earth. Mitchell started an organization called the Institute of Noetic Sciences, which studied metaphysical subjects. (NASA at KSC.)

SHEPARD PLANTS FLAG. Astronaut Alan B. Shepard Jr., *Apollo 14* commander, stands by the U.S. flag on the lunar Fra Mauro Highlands during the early moments of the first extravehicular activity (EVA-1) of the mission. Shadows of the lunar module *Antares*, astronaut Edgar D. Mitchell (the lunar module pilot), and the erectable S-band antenna surround the scene. This was the third American flag to be planted on the lunar surface. (NASA at KSC.)

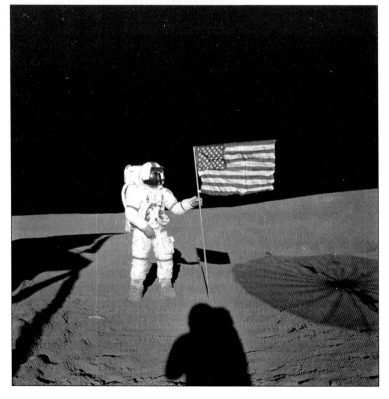

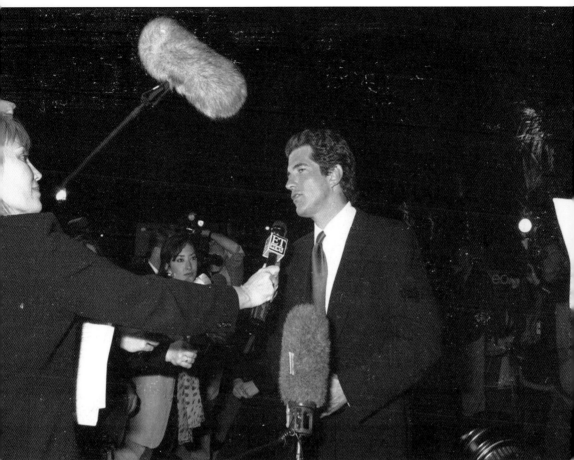

JOHN F. KENNEDY JR. Kennedy Jr., editor-in-chief of *George Magazine*, speaks with members of the national media at the Home Box Office (HBO) and Imagine Entertainment premiere of the 12-part miniseries *From the Earth to the Moon* at Kennedy Space Center. The series was filmed in part on location at KSC and dramatizes the human aspects of NASA's efforts to launch Americans to the moon. The miniseries highlights NASA's Apollo program and the events leading up to and including the six successful missions to the moon. (NASA at KSC.)

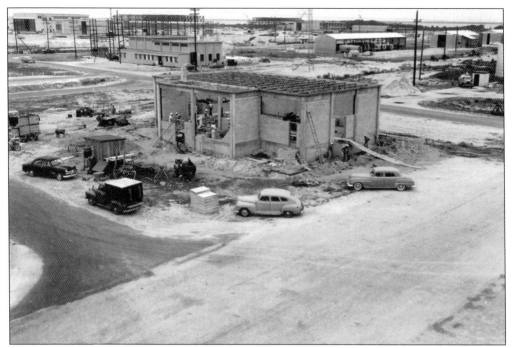

TELEPHONE EXCHANGE BUILDING. This early picture shows the first communications building at the budding rocket industry. This building, being constructed in the 1950s, was to house the early telephone exchange. (45th Space Wing History Office.)

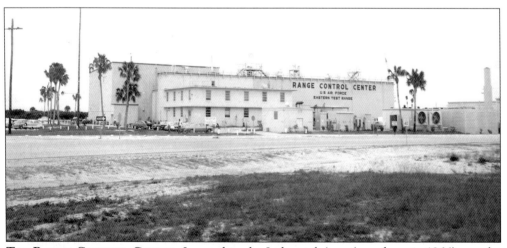

THE RANGE CONTROL CENTER. Located in the Industrial Area (seen here in 1966) was the nerve center of the cape, monitoring all launches and connecting the tracking stations. The range safety officer was located at this facility. (45th Space Wing History Office.)

Launch Complex 39
Operations Support Building
Groundbreaking Ceremony

John F. Kennedy Space Center
September 2, 1988
9:00 a.m.

NASA

AREA 39. These historic grounds have seen a lot of development and events: a French fort from the 16th century, a Harvard Alumni Canaveral Club, monumental space launches, the building of this facility, and the Vehicle Assembly Building. Local construction company WJ Construction, a space contractor, built this and many other facilities at the cape. (WJ Construction.)

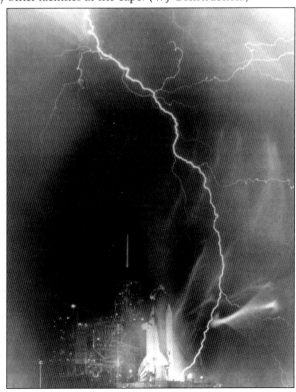

ENERGY AT COMPLEX 39. A powerful electrical storm created an eerie tapestry of light in the skies near Complex 39A in the hours preceding the launch of STS-8. (NASA at KSC.)

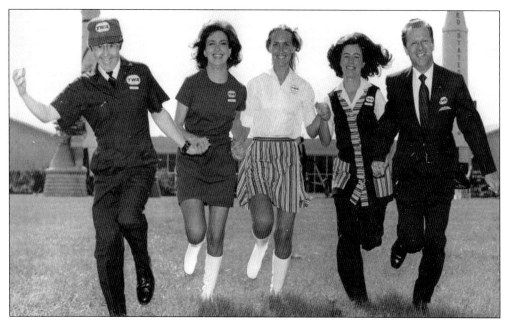

New Uniforms of TWA/NASA Tours. The uniforms at the TWA/NASA Tour have changed, reported Harry B. Chambers, TWA/NASA Tour project manager. Shown in front of the Visitor Information Center in the different new uniforms are, from left to right, Jim Taylor, Jackie Sullivan, Leah Neilson, Carol Calhoun, and Walter Cobb. (NASA photograph; Joe Morgan.)

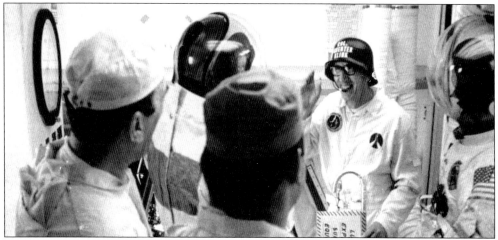

"Führer of the Pad" Gunter Wendt. During the Apollo era (1967–1975), Wendt was nicknamed "pad leader" or "Führer of the Pad" by the Kennedy Space Center personnel for his strict but good-humored leadership. The first man on the moon, astronaut Neil Armstrong, upon reaching the White Room on July 16, 1969, received a crescent moon carved out of Styrofoam from Wendt, who described it as a key to the moon. In return, Armstrong gave Wendt a ticket for a "space taxi" good between two planets. Gunter was born in Berlin, Germany, in 1924. He immigrated to the United States in 1949 and became a citizen in 1955. Gunter worked for McDonnell Aircraft during the Mercury and Gemini manned space programs supervising spacecraft launch preparations at Cape Canaveral. He became an engineer in charge of the NASA launch pads. He was the last person seen by the astronauts before liftoff. He is a personal friend of many astronauts and a recipient of NASA's Letter of Appreciation award. (NASA at KSC.)

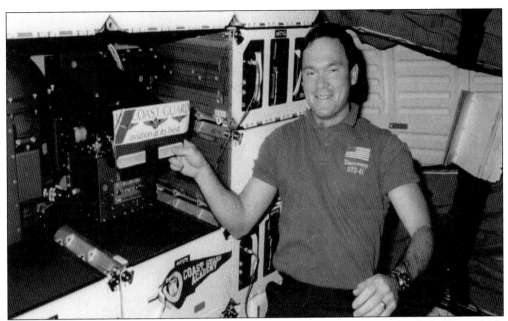

A Future Vice President at United Space Alliance. Bruce E. Melnick displays a U.S. Coast Guard decal. Melnick, who is a graduate of the Coast Guard Academy and the first ever active Coast Guardsman to fly in space, draws attention to his branch of the service while posing next to a banner from his alma mater and a Coast Guard decal. (NASA at KSC.)

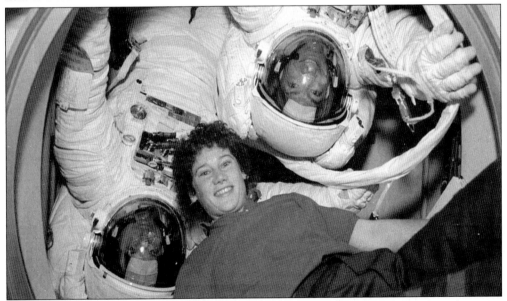

Susan J. Helms, A General to Be. STS-54 mission specialist Greg Harbaugh and mission specialist Mario Runco, both wearing their spacesuits, pose with mission specialist Susan Helms as they emerge from the mid-deck airlock with Helms's assistance. Susan J. Helms was the first American military astronaut and held the world record for a single space walk (8 hours, 56 minutes). She is also the first woman to be a resident at the International Space Station. At the time of this writing, Helms is the commander at the 45th Space Fighter Wing at Patrick Air Force Base, holding the rank of major general. (NASA at KSC.)

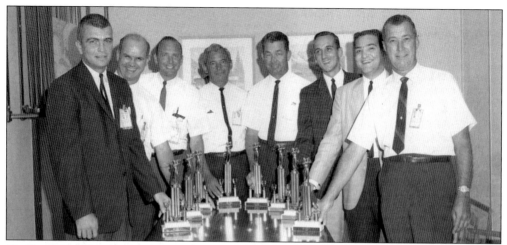

ON PAR WITH NORTH AMERICAN AVIATION. The presentation of a golf award to NAA (North American Aviation) Twightlight Golf league includes, from left to right, A. G. Grier, T. Hosel, K. Street, B. Bigelow, B. Winchester, R. Kinsman, V. Daniello, and D. M. Moe. NAA was a major U.S. aircraft manufacturer and responsible for a number of historic successful aircraft. As an early space contractor, they were involved in a number of rocket projects. The Rocketdyne Division of NAA developed the Redstone rocket, responsible for America's first orbiting satellite, *Explorer 1*. NAA designed the X-15 rocket plane as well as Apollo Command and Service Module, the second stage of the *Saturn V* rocket, the space shuttle orbiter, and the B-1 Lancer. North American Aviation was later absorbed into Boeing Aircraft. (NASA photograph; Joe Morgan.)

CORVETTE RACES. Astronauts Pete Conrad (left), Dick Gordon, and Al Bean (right) pose with one of their matched set of Corvettes in the parking lot of Spaceport's Flight Crew Training Building following their training exercises in the Apollo mission simulators. Oral histories tell that many of the astronauts had Corvettes provided by a local auto dealer and would race each other along the state road heading to the space center. Pictures not in this book show Wally Schirra receiving his honorary Cape Kennedy Corvette Club flight jacket. (NASA at KSC.)

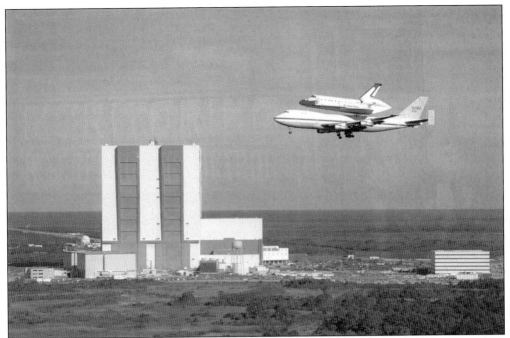

RIDING PIGGY BACK. Here the space shuttle STS-32 returns to the Kennedy Space Center atop the Shuttle Carrier Aircraft. The duo flies by the Vehicle Assembly Building (VAB). (NASA at KSC.)

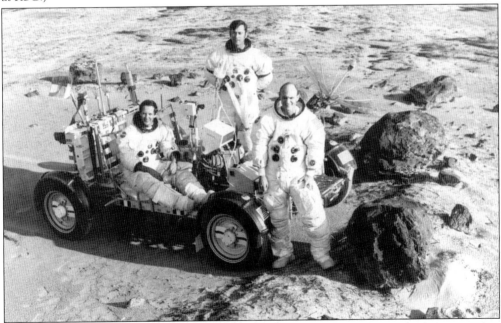

TRAINING AT THE CAPE. The cape area provides excellent real-time training for terrain that is somewhat similar to the moon. Here *Apollo 16* astronauts—Lunar Module pilot Charles M. Duke (left), Cmdr. John W. Young (center), and Command Module pilot Thomas K. Mattingly II—prepare for the Lunar Landing Mission during a training exercise. The lack of helmets gives away the fact that they are not on the moon. (NASA at KSC.)

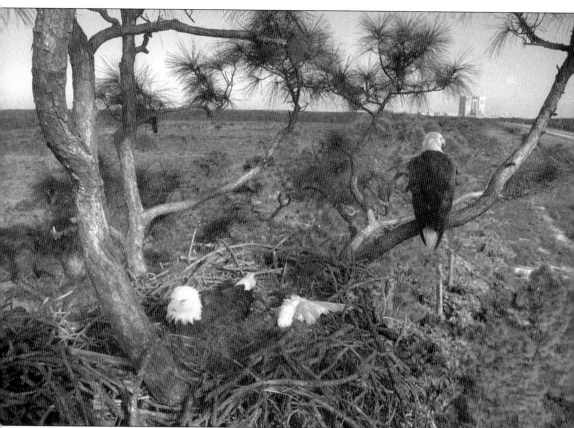

THE EAGLES HAVE LANDED. There is a multitude of biodiversity living in harmony with the space activities at the cape. This is one of a series of pictures documenting the daily lives of two of KSC's most famous residents: the southern bald eagles. According to wildlife experts, eight to nine pairs of bald eagles inhabit nests at KSC. (NASA at KSC.)

Five

A NEW CITY
THOSE WERE THE DAYS, MY FRIENDS

SUN AND SPACE FESTIVAL. Beauty contestants assist Cape Canaveral mayor Richard Thurm as he uses scissors for ribbon-cutting ceremonies, officially opening the 1967 Sun and Space Festival. This chapter tells of the history of this new city called Cape Canaveral.

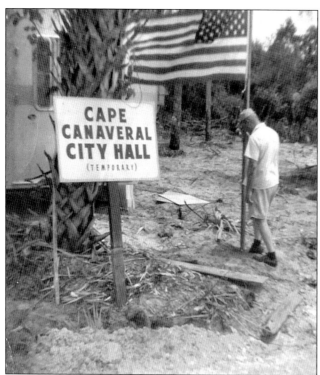

THE FIRST CITY HALL. On July 4, 1962, the first city hall for the City of Cape Canaveral was at a mobile home. Arty Scaborozi plants a flag outside for this auspicious day. The city of Cape Canaveral got its start when in 1961, a committee was formed to set into motion the incorporation of a new town. The chairman of this committee was Raymond Jamieson. The founding meeting was held at the Tropicana Orange Juice Plant at Port Canaveral on March 10, 1962. At the meeting for this first election were 215 eligible freeholders. Results from the election resulted in 152 people for incorporation. Later the council meetings were held at the Cocoa Palm Recreation Room. (Joni Mitchell.)

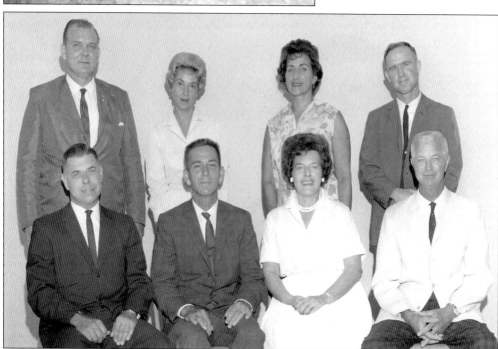

THE POLITICAL MACHINE. From left to right are (first row) Richard Thurm (mayor), Eugene Jandreau, Fran Jamison, and Jack Hurck (city council); (second row) Dr. Paul Jahn of the city's health division, Donna Anderson (clerk), Anita Ostrom (finance), and Jim Morgan (building department). (Ann Thurm.)

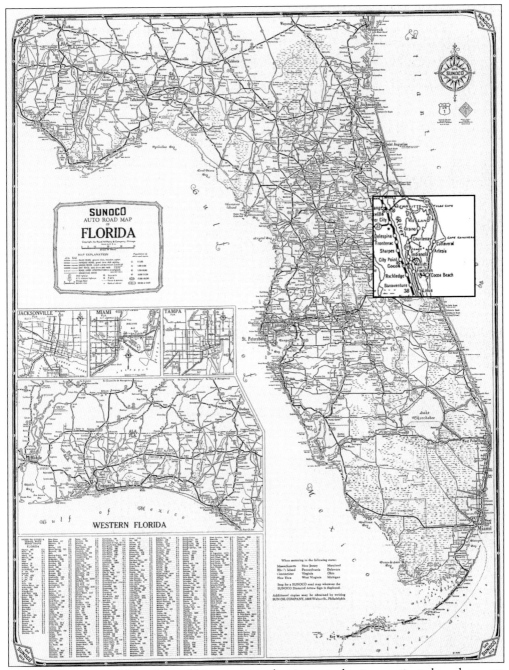

ARTESIA IS ON THE MAP. An oral history states that in an early city meeting when they were trying to decide on name for the city, a lady from California reviewed the choices and said, "Where's Artesia?" A young man jumped up and said "You're standing in it, this is Artesia!" In this old highway map, the name Artesia made the map along the coast just south of Canaveral. (Gary and Carolyn Zajak.)

WHAT TO DO AND SEE in the Cape Kennedy area

June, 1966

Complete Visitors Handbook To:
Cocoa, Cocoa Beach, Cape Canaveral, Merritt Island, Eau Gallie, Satellite Beach, Indian Harbour Beach, Melbourne, Melbourne Beach, Indialantic, Palm Bay & Titusville

WHAT'S IN A NAME? Just after the assassination of John F. Kennedy, the new president, Lyndon B. Johnson, to honor the late president, used an executive edict to change the name of the area from Cape Canaveral to Cape Kennedy. This took effect in December 1963. Immediately there was an outcry from many VIPs in the community. Florida Historical Society was quick to act by drawing and passing a resolution in the same month asking that Canaveral be retained as the name of the cape. Judge James R. Knott, a past president of the Florida Historical Society, pledged a concerted effort to restore the ancient name. (Joe Morgan.)

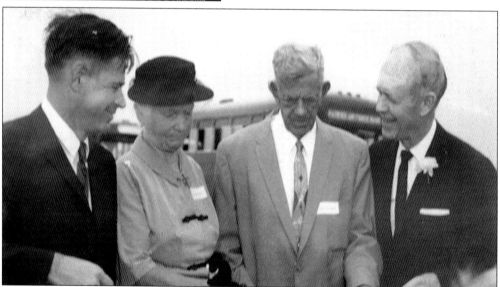

EMORY BENNETT HIGHWAY DEDICATION. The newly opened State Road 528 is named the Emory Bennett Causeway on October 19, 1963. The keynote speaker at the causeway dedication was Florida governor Farris Bryant, and the ceremony was held at the tollbooth on the west side of the Banana River. This initiative, started by Bennett's family and the Cocoa Chapter of the Kiwanis Club, resulted in the highway being named in honor of Brevard County's first and only Medal of Honor winner, Emory Bennett. He was awarded the Medal of Honor for his valiant fight on June 24, 1951, in Korea against two battalions of enemy soldiers, where he made the supreme sacrifice. (John Bennett, brother of Emory Bennett.)

SERVING POWS. Elizabeth Scobie was awarded the Cape Canaveral Air Force Association (AFA) citation for outstanding services as a DAR (Daughters of the American Revolution) leader of a joint effort with AFA to assist American prisoners of war in Vietnam and their families. The award was presented on March 24, 1970, by retired major general Dan Calahan.

GLAMOUR SHOT OF NONIE FOX. Local resident Nonie Fox, descendant of the Knutson and Chandler families, married a photographer, who was a good source for pictures in this book. After raising five children, she went into real estate and had other jobs, including working in special education. Both she and her husband, Arthur, were involved in the local theater. (Nonie Fox.)

THE REAL EIGHT'S MUSEUM OF SUNKEN TREASURE. In 1967, an 18th-century ax found on a shipwreck site was used to break the ground for a planned $500,000 Museum of Sunken Treasure at Cape Canaveral (shown here in an architectural drawing). Treasure hunter Kip Wagner and the seven members of the Real Eight Company planned a new museum to exhibit their salvage operations finds from the 1715 plate fleet. The Spanish fleet of ships was comprised of 12 ships, with all but one wrecked by a 1715 hurricane in the Sebastian area of Florida. The architectural firm of Stottler and Stagg designed a unique round building in a style called King Solomon's Mine. (CCC.)

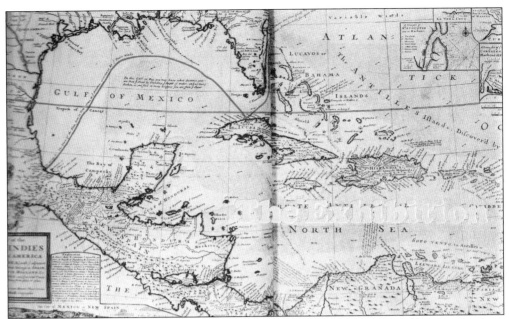

INSIDE WAS GOLD, SILVER, AND FINE ORIENTAL PORCELAIN. A visitor walking in the front door was greeted by a huge replica of the *Hampton Court*, a British ship used in the 1715 fleet. Above on the ceiling was a huge treasure map of the Caribbean showing the route of this treasure. Other exhibits showed how the Spanish would refine the gold and silver. (John Harmer/ Lund Humphries.)

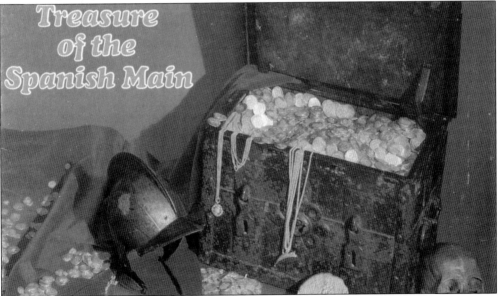

TREASURE BOOK. Here is a brochure with the story and pictures of the 1715 plate treasure fleet. Inside the museum, exhibits showed the various steps used in refining and shipping the Spanish treasure. There were displays of gold, silver, and pottery and models of ships and artifacts. Prior to the opening of the museum, the treasure was exhibited at leased rooms of a bank in Satellite Beach. The treasure was also featured in the January 1965 issue of *National Geographic*. (John Harmer/Lund Humphries.)

THE STORY OF THE 1715 TREASURE. The museum had nine dioramas designed by Robert Marx, a specialist employed by the Real Eight Company. The exhibits traced the stories of the recovery of the treasure. A visitor would pass through a circular hallway where they would view seascapes complete with coral reefs, rocking ships, and other realistic underwater scenes. (Terry Armstrong.)

TREASURE CHEST. Treasure is all that is left of a treasure chest when it is salvaged from the ocean floor. Silver coins get fused together and conform to the original chest, which has long rotted away. A treasure trove like this was exhibited at the museum until it was part of a great treasure heist on September 20, 1976. The *Florida Today* newspaper reported the story with a title that read "Thieves Steal Museum Gold Worth $750,000." The museum declined after this heist and eventually went out of business. The crime is still unsolved at the time of this writing. Oral histories state that Carl McIntire's ministry called "Gateway to the Stars" next door ruined it for many tourists with their constant evangelism. (Del Long.)

ANOTHER KIND OF TREASURE. Local businessman and real estate developer Jim Morgan acquired the building of the Museum of Sunken Treasure in November 1982. Jim Morgan (right) poses with his wife, Virginia, and country/western entertainer Leon Everette. Morgan turned the location into an entertainment establishment called Diamond Ginny's after his wife. It featured the world's longest bar with 200 feet of bar seats on upper and lower levels and 600 square feet of dance floor. (Jim Morgan.)

THE WAITSTAFF AT DIAMOND GINNY'S. The cocktail waitresses at Diamond Ginny's had cute outfits complete with a little toy gun tucked away in their garters. Featured at this establishment were some of the top names not only in country/western talent but blues and some rock and roll. The entertainment lineup included the following: Tammy Wynette; Charly McClain; Joe Realino; Ink Spots; Blood, Sweat, and Tears; and BB King. (Jim Morgan.)

INK SPOTS. Many local space contractors and employees would visit this watering hole; even the employees for Lockheed Martin had their 1984 Christmas party here. A "Wednesday Friends Day" brought a connectedness to the business community. On a more solemn occasion, family members of the crew of the space shuttle mission 51-L saw the explosion that led to its tragic ending from the parking lot of this establishment. (Jim Morgan.)

POINTING THE WAY TO SOLAR RESEARCH. In front of the Florida Energy Center sign on Beeline, US 528, H. Harrensin, the center director, points the way in September 1975. The Florida Solar Energy Center had easy access to the new Highway 528, called the Beeline, a direct route that connected Orlando, Florida, to this important area. For many years, Cape Canaveral was home to the Florida Solar Energy Center (FSEC). In the inaugural address of Gov. Reuben Askew, he said, "The genius of the Kennedy Space Center that placed men on the moon can be dedicated now to resolution of the serious energy problems that afflict us all. Just as Florida played a pivotal role in space research, so too can we play a vital role in the solar research that is necessary if we are to find those new sources of energy." (Florida Solar Energy Center.)

PRESIDENTIAL CANDIDATE'S VISIT ON SOLAR ENERGY. From left to right, Jerry Lowery, Marvin Yarosh, and Howard Harrenstein are seen during candidate Jimmy Carter's visit to FSEC in 1976. After Jimmy Carter was elected president, he declared a war on energy and established a national energy policy. Under his administration, the solar budget was the largest, at $833 million in 1980. The solar budget dropped to $401 million in 1982 under President Reagan. (Florida Solar Energy Center.)

AERIAL VIEW. Shown here are the Cape Canaveral facilities of the Florida Energy Center in June 1979. On these grounds, many tests were conducted in tapping into alternative energy. It was applying science for the benefit of all mankind. (Florida Solar Energy Center.)

HERE COMES THE SUNDAY. Marvin Yarosh (left), David Block (center), and Jim Rolan are seen at the burial of a time capsule during a SunDay event in May 1984. FSEC held its first SunDay open house in April 1979; this became a very successful annual springtime event for the center while it was headquartered at Cape Canaveral. Hundreds of members of the general public attended the Saturday events to learn about solar technologies, equipment, and concepts. (Florida Solar Energy Center.)

MAKING IT HAPPEN, THE MAINTENANCE MAN. Jim Gorman (with his back to the camera in April 1974) was always there to assemble and help set up experiments. He lived in an older home left over from the 1950s building boom in Cape Canaveral. Gorman went on to the movie industry but hurt his back moving equipment. He said he liked his period working at Florida Solar Energy while it was at the cape. (Florida Solar Energy Center.)

CAROL EMRICH AND ROSS MCCLUNEY AT DAYLIGHT AVAILABILITY MEASUREMENT STATION. In 1982, FSEC constructed its Daylight Availability Measurement Station, which measured 36 channels of solar radiation and daylight, including direct beam radiation, global horizontal radiation, diffuse sky radiation, and radiation falling from the sun on vertical planes facing north, south, east, and west. Dr. McCluney, seen here in August 1988, was involved in the early Earth Day events and wrote a number of books on the impact of pollution and the need to achieve sustainable living. (Florida Solar Energy Center.)

CHRISTMAS IN 1988. City manager Leo Nicholas enjoys the 1988 Christmas party with city hall staff. From left to right are Lyle Waltemire, superintendent of wastewater, Santa (Bob Hoog), city manager Leo Nichols, city clerk Jan Leeser, and an unidentified employee. (CCC.)

SISTER CITIES. City of Cape Canaveral officials received a plaque from their sister city, Guidoinia, Italy, in 1988. From left to right are Pres. Giovan Battista Lombardozzi of Guidoinia, Mayor Pat Lee, Rocky Randles, unidentified, Sandy Randles, Jeff Kidd, Mayor Pro Tem Bob Hoog, unidentified, and Steve Miller. The sister city program was designed to encourage goodwill and tourism to the area. Other cities in the program include Vila do Bispo, Portugal; Ithaca, Greece; and Kloter, Switzerland. (CCC.)

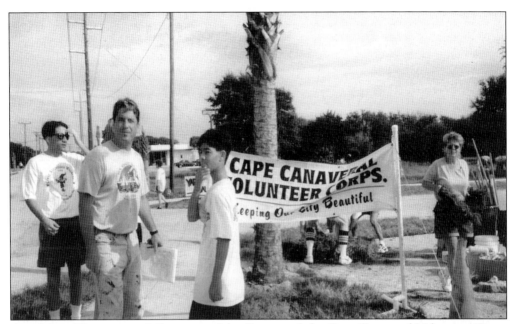

ANY MORE VOLUNTEERS? City mayor John Porter and the Cape Canaveral Volunteers Corps are involved in a variety of city projects, including tree, mangrove, and sea oat planting. "A tree-lined residential community" was the theme for the city of Cape Canaveral for many years. John Porter was the youngest mayor of the city and was interviewed by *20/20* about his concerns of the welfare of the local community from the launch mishaps of the space industry. (CCC.)

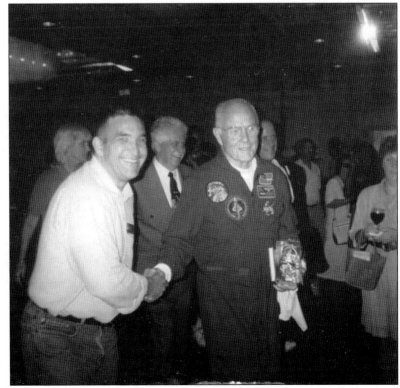

JOHN GLENN REVISITS. Cape Canaveral city councilman Tony Hernandez III shakes hand with senator and astronaut John Glenn during his visit in 1998. On October 29, 1998, John Glenn, at age 77, became the oldest person to fly in space.

MOON HUT. This is a space shot over the Moon Hut, a favorite eatery among locals and space enthusiasts. It was reported that CBS anchorman Walter Cronkite would interview some of the original Apollo astronauts over a cup of coffee there. Pictured is a NASA flight crew enjoying breakfast. (La Fiesta Restaurant.)

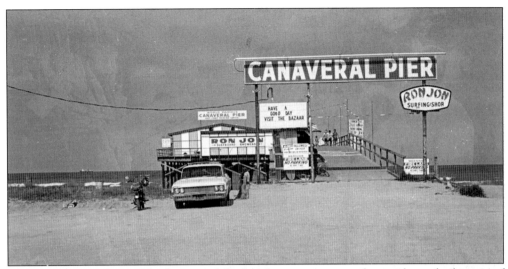

RON JON'S SURF SHOP. The history of the local area is not complete without the history of surfing and the people and businesses behind it. Located at the entrance to the Canaveral Pier, Ron Jon's started selling surfboards and beach apparel to locals in 1963. Founder Ron DiMenna from New Jersey originally started selling surfboards from a trailer in Long Beach Island, New Jersey, and later opened his first store there in 1961. After the Cocoa Beach store, expansion led to stores in Orange, California; Fort Lauderdale, Orlando, and Key West, Florida; and Myrtle Beach, South Carolina. DiMenna, an avid surfer, was inducted into the Surfers Hall of Fame in 1998. (Ron Jon.)

SURF'S UP. Pat O'Hare (foreground) catches a swell with other surfers. Surfing started in the local beach area in the early 1960s. Surfers like Dick Catri, Jack Murphy "Murph the Surf," and Gary Propper brought surfing into the limelight. This area produced outstanding surfers, including six-time world champion Kelly Slater, and other touring pros, such as Bryan Hewitson, Matt Kechele, Jeff Crawford, and Todd Holland. In his first full year on the tour (1992), at age 21, Slater claimed the world title. In addition to surfing, many surfers would support themselves by building and selling surfboards. Pat O'Hare moved here in 1963 to fulfill his dream of surfing and making surfboards, which he still does at the time of this writing. (East Coast Surfing Museum.)

PATRIOT'S DAY. An annual celebration in honor of the final naval battle of the American Revolutionary War off the coast of Cape Canaveral was started on October 9, 1990. A resolution was signed by Brevard County commissioner Carol Ann Senne declaring the second Saturday of March Patriot's Day. This was for the final naval battle of the Revolutionary War fought by Captain Barry of the *Alliance* off the coast of Cape Canaveral. (CCC.)

SONS AND DAUGHTERS OF THE AMERICAN REVOLUTION. The local SAR and DAR chapters always had color at events with their period dress. Ladies are dressed as Betsy Ross. This Patriot's Day parade gave everyone an opportunity to show their patriot pride. Dr. Harold Gillig, who got this celebration started, penned it perfectly in his poem: "Every right to show, not hide, this thrill of patriotic pride." (DAR Chapter.)

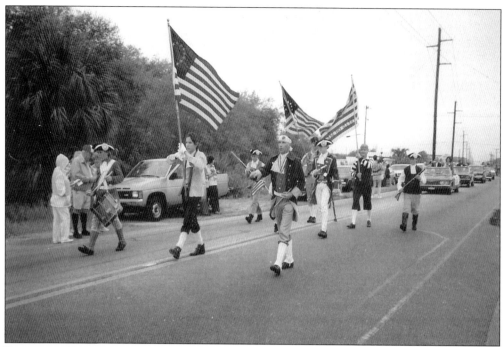

PATRIOTISM EXHIBITED. At the annual Patriot's Day parades, there were colorful floats, color guards, dignitaries, and a naval band. The parade would proceed on North Atlantic Avenue and march through various points in Cape Canaveral and Cocoa Beach every year until 2004. (CCC.)

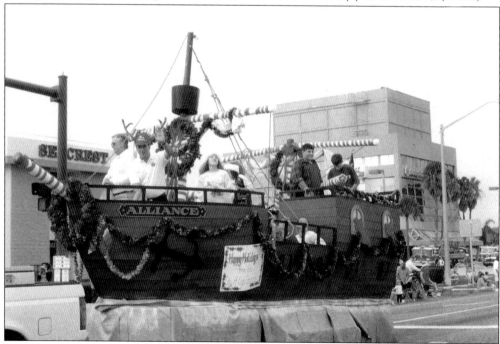

MOCKUP OF THE ALLIANCE. A replica of the *Alliance*, the American frigate in the final Revolutionary War naval battle, was built by Carl Akery (foreman) and helpers in the city's street department. Riding the float is councilman Buzz Petzos (left foreground, waving). (CCC.)

BREAKING NEW GROUND. Surveyors from Brevard Engineering lay the land for the newly built Chrysler Building.

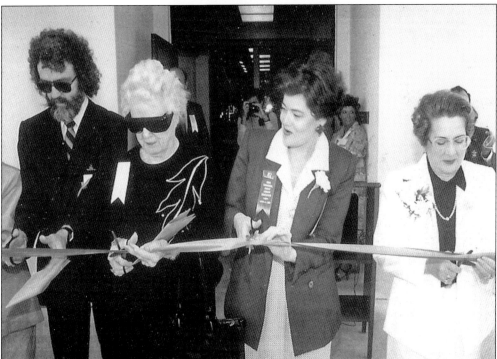

BUILDING A LIBRARY. Local city officials break ground to build the library on January 16, 1988. Months later, a ribbon-cutting event shows former mayor Joy Salamone laughing. The library was built by G&S Contractors. The mayor at the time was Patrick Lee. (Cape Canaveral Library.)

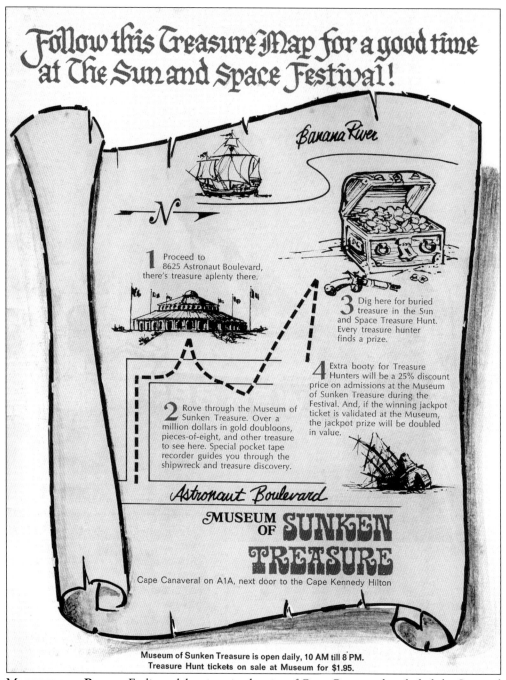

MAPPING THE ROUTE. Earlier celebrations in the city of Cape Canaveral included the Sun and Space Festival. This map shows a route that includes the Museum of Sunken Treasure that was once in the city. (Ann Thurm.)

TEACH THE YOUNG WELL. A local elementary school in Cape Canaveral, Cape View, educated the young children of local residents. Here Robert Willson, an aerospace specialist, visits Cape View Elementary School and gives a space presentation to fourth and fifth graders in February 1977. (Both, Ann Thurm.)

LIFE IS GREAT AT CAPE CANAVERAL. Local professional John Galt is pictured above in Taiwan, China. Galt and his wife, Gail, celebrate the Fourth of July at the port (left). John was a crystal consultant who went all over the globe working for different technical companies to utilize crystals in industrial applications. He and his wife bought a home on Holman Road in Cape Canaveral. Gail worked at the Florida Solar Energy Center. (Gail Galt.)

Six

ONE FLEW OVER, MISSILES THAT IS

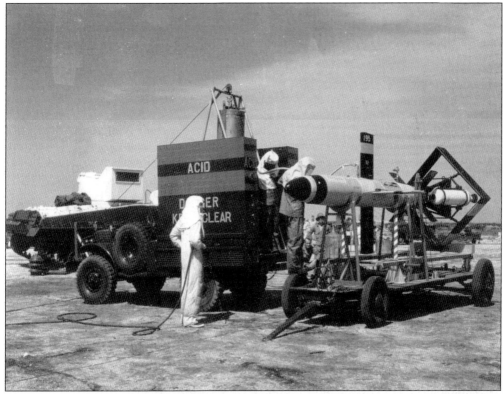

UP CLOSE AND PERSONAL. This Sherman tank has its gun removed and periscope put in its place so as to be used for a blockhouse for the Lark missile launch. Being up close is important for filming and research, so this makeshift blockhouse was made. (Al Hartmann.)

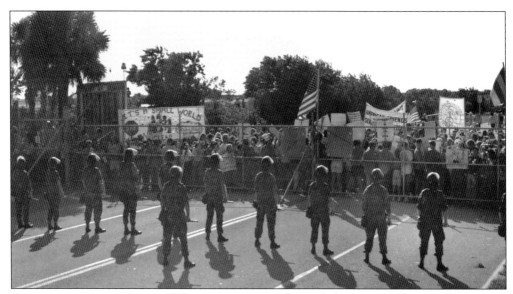

PROTESTORS AT THE GATES; "WONDERFUL CHAOS." A mile-long crowd of over 4,000 activists marched to the Cape Canaveral Air Force Station to protest the latest launch of a Trident 2 missile. As the marchers were softly singing, "All we are saying is give peace a chance," they were greeted at the gates with whirling helicopters, revving airboats, and taunting counter-demonstrators. There were homemakers, teenagers, grandmothers, priests, hippies, and young children wearing T-shirts with the slogan, "Bread not bombs." Arrests numbered 138 people. (45th Space Wing History Office.)

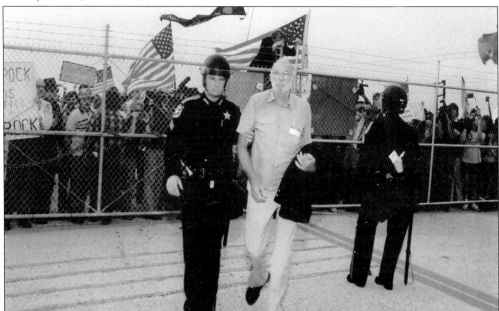

SPOCK ARREST. Acclaimed author and pediatrician Benjamin Spock arrived at Jetty Park to join 150 activists. These activists had just completed the 217-mile Florida Peace Pilgrimage from Kings Bay, Georgia. In Spock's speech, he said, "The fact that the launch went off successfully makes the rally particularly appropriate. The question is not the success of the launch but the future of our world." (45th Space Wing History Office.)

Seven

EVERY SHIP, OF ANY SIZE IN THE WORLD

COAST GUARD LIFE SAVING STATION ON EAST BEACH. The story of local maritime history is rich and includes an incredible development called Port Canaveral. This port was envisioned back in the 19th century and after delays and hard effort was finally dug in the 1950s with a dedication on November 4, 1953. In this 1930s picture outside the Coast Guard Life Station on East Beach, a newspaperman interviewed boatsman mate George M. Quarterman Jr.on July 4th. He explained all the multiple colored flags on display along Ocean Boulevard for the Fourth of July. He said, "They're international code flags and every ship of any size in the world has a set. They mean the same thing in all languages. We arranged them haphazard for full dress of the Fourth," said Quarterman. "We dress up for Washington's birthday too." (Nonie Fox.)

BREAK ON THROUGH TO THE OTHER SIDE. This was a quiet but very important event in Brevard County history. The opening of a sea channel resulted in the first waters flowing to the Banana River. This was a dramatic episode of seeing the culmination of nearly a century worth of planning, preparing, and disappointments. Historic newspapers around the country demonstrated the agendas of hundreds of people regarding this port. (45th Space Wing History Office.)

GETTING READY TO DIG THE PORT. The first port commissioners were Abe Fortenberry, Bob Geiger, Noah Butt, Sam Knutson, and Ben Lewis, seen here in 1951. These men were the movers and shakers of their time. Sam Knutson is written about in this book, and Ben Lewis was an active and key member of a local Seventh-day Adventist church. (Canaveral Port Authority.)

PORT DEDICATION. After just less than 100 years of talk and efforts, the moment arrived on November 4, 1953, when Port Canaveral held its dedication ceremony. Attending this event were many officials in high office and over 6,000 people. Sen. Spessard Holland was a keynote speaker, and Bernard Parrish of Titusville acted as master of ceremonies. Speeches were kept short. Col. Noah Butt said, "This day marks the fulfillment of an aim of almost a century—this dedication and opening of this port to the commerce of the world." The ceremony started at 10:00 a.m. and ended just after noon; a fish fry and other activities were waiting, including a visit from a naval Cannon-class destroyer escort called the USS *McClelland* (DE-750), which local citizens were permitted to board and inspect. (Canaveral Port Authority.)

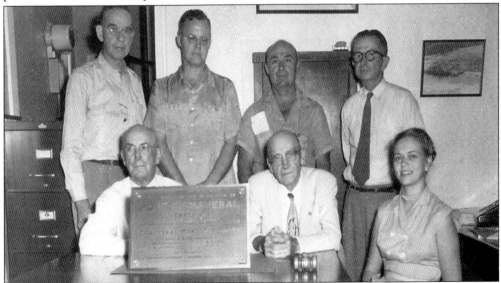

THE TEAM. From left to right are (seated) executive treasurer N. M. Agrabite, chairman N. B. Butt, and secretary Barbara Smith; (standing) vice chairman A. A. Dunn and commissioners G. W. Lycock, Dave S. Nisbet, and L. M. Carpenter. Years later in 1983, a new wing at Port Canaveral was opened and dedicated to Barbara Smith, then director of operations and administration, in recognition of her long service to the port. The 2,000-square-foot addition was completed at a cost of $85,546. (Canaveral Port Authority.)

GOT JUICE? Tropicana, a citrus processor company, has a plant at Port Canaveral to service the area's citrus industry. By 1957, their ship, the SS *Tropicana*, was carrying 1.5 million gallons of juice to New York each week. In 1958, the *Tropicana* accidentally rammed and damaged the west marginal wharf. To recover the repair costs, a lawsuit followed, resulting in the largest jury award in Brevard County. (Canaveral Port Authority.)

TRIDENT SUBMARINES. The U.S. Navy uses the Trident Turning Basin for all its water operations at the port. The Trident Turning Basin is used by U.S. Navy Fleet Ballistic Missile submarine forces. The berths situated on the inner reach of the entrance channel are used primarily by cruise ships, cargo ships, and tankers. The primary U.S. Navy facilities at Port Canaveral consist of the Trident Wharf on the east side of the Trident (East) Turning Basin, the Poseidon Wharf on the southeast side of the Central Turning Basin, and the Military Traffic Management Command (MTMC) Wharf on the north side of the Central Turning Basin. The berths are designed to safely moor a vessel in winds up to 61 knots (70 miles per hour). Trident Wharf, constructed between 1975 and 1977, is an operational facility in support of the U.S. Navy Fleet Ballistic Missile Submarine Program. The wharf is 1,220 feet (372 meters) long and 68 feet (21 meters) wide. (Canaveral Port Authority.)

ATTENTION ON DECK, THE PRESIDENT'S HERE. President Carter docked at Port Canaveral on May 28, 1977, and confidently planted atop the two-and-a-half-story conning tower (a raised platform on a ship or submarine, often armored, from which an officer can give directions to the helmsman) of the nuclear submarine that took him and the First Lady on a nine-hour cruise. Adm. Hyman Rickover stood by his side. "I believe with absolute certainty I can say there is no finer ship in the world than this one," said Carter. "Eventually we might find some opportunity to completely eliminate nuclear weapons but until then the US nuclear powered submarine force will be needed to serve the peace keeping role it has held for 25 years." (45th Space Wing History Office.)

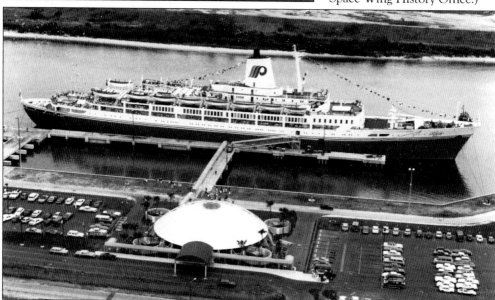

THE STARSHIP ROYALE'S INAUGURAL VOYAGE, MARCH 1984. There have been many celebrations of famous ships at Port Canaveral. Among the more famous ships making this their port of call are the *QE 2* (Queen Elizabeth II) from the United Kingdom. The largest celebration was held July 28, 1998, when Disney launched its first ship, the *Magic* from Port Canaveral; this was followed years later by another Disney ship called the *Wonder*.

CASINO SHIPS AT THE PORT. Pictured are, from left to right, Chuck Rowland and Ray Sharkey from the port and Archie Cox and John Brevick from Sterling Casino. The first casino vessel at Port Canaveral was in the early 1990s and called the *Diamond Royale*, which was sold after a couple of years to SunCruz Casinos and became the *SunCruz VII*. It was later replaced with a larger ship, the *SunCruz VIII*. SunCruz went through Chapter 11 bankruptcy and was sold. Sterling Casino first sailed September 11, 1998, when it launched the *New Yorker* a temporary ship. A year later in 1999, they launched the *Ambassador II* (pictured below) and billed itself as the world's largest casino ship; it still is at the time of printing. (Sterling Casino Lines.)

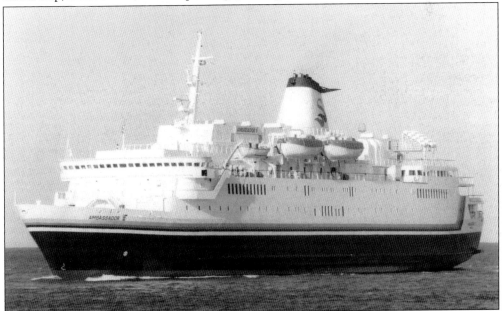

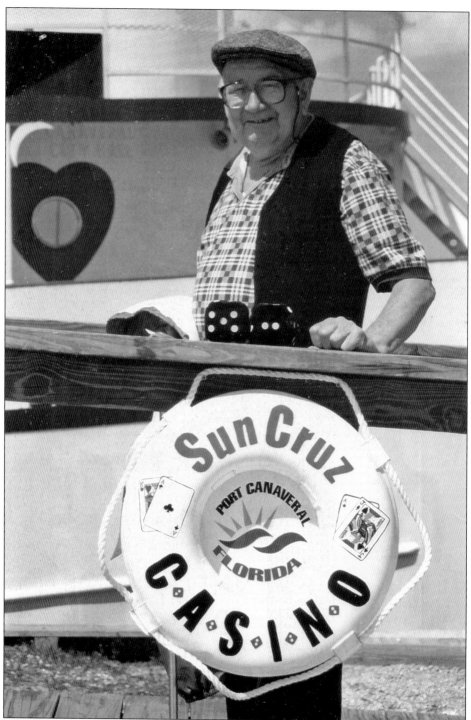

A High Roller on the High Seas. Local Cape Canaveral resident John Kachuba is seen aboard the *SunCruz* casino boat. His favorite game was craps, and he enjoyed a day of gaming once a week. He preferred the *SunCruz* because he liked the people and it was easy for him to get around onboard. (Gail Galt.)

Eight

HOUSEHOLD OF FAITH

THE HOUSEHOLD OF FAITH. The pillars of a community are its churches and religious community. As early as the 1920s, churches have played an important role in the area's development since a band of Seventh-day Adventists from Pensacola, Florida, pioneered the area. One way or another, the religious community made their mark in Cape Canaveral.

GATEWAY TO THE STARS. Televangelist Carl McIntire from Cape May, New Jersey, moved his ministry and four-year Bible college called Shelton College to Cape Canaveral in the 1970s. With a fresh start next to the space center, his new venture was called Gateway to the Stars. This was just after the Apollo program ended, and real estate values were low, so he was able to acquire the Cape Canaveral Hilton at a good price. The hotel, renamed the Freedom Center, had several Bible exhibits, including a scale model of the original Temple of Jerusalem from the Canadian Expo in 1967. (Rev. James L. Blizzard.)

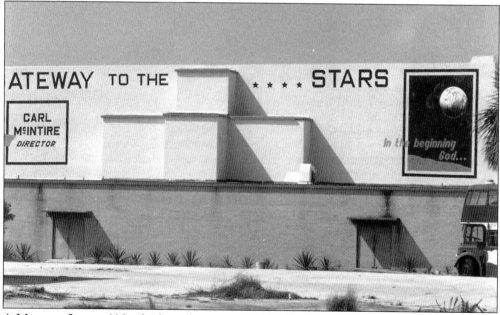

A MIRACLE INDEED! Not far from this ministerial building, another ministry got its start. The Space Coast Seafarers ministry at Port Canaveral was able to acquire an old post office building at a reduced rate. The acquisition was a miracle in itself as the sale price was originally $270,000 and was reduced as a tax write-off to the ministry for $70,000. (Rev. James L. Blizzard.)

CHAPEL IN THE WILDWOOD. A congregation of Seventh-day Adventists moved to the area from Pensacola, Florida, in the early 20th century and built a church at the cape. The newspaper often reported on the activities, which were not just religious but also were social and intellectual in nature. Because the Seventh-day Adventists worship on a Saturday, they were able to let other denominations use their facilities on Sundays, which was helpful to get other churches started. The *Cocoa Tribune* reported on the move of the SDA church on February 9, 1933: "The Adventist Church has received a gift from Mrs. James Merchant of her former home on the county road. The present church at Whidden Center will be taken down and used to remodel this building, which will become the future home as the Canaveral Adventist Church." (Rev. James L. Blizzard.)

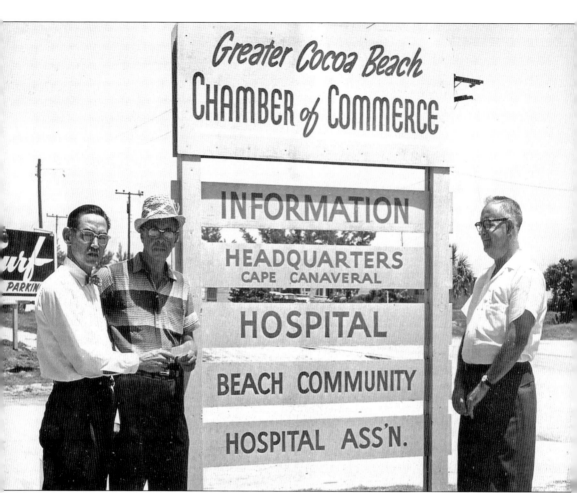

A GIVING CHURCH. Christ Lutheran Church gives another check to Cape Canaveral Hospital from its sunrise service fund. Dr. L. C. Beal, church treasurer (left), presents the check to Ed DeNike, hospital board member, as church president Paul Godke observes. (Christ Lutheran Church.)

Nine

TIME PASSAGES
LINKS WITH THE PAST

TIME PASSAGES; LINKING THE PRESENT TO THE PAST. This chapter offers a look at how history survives the sands of time. From archaeology to monuments, from dedicated historians to artistic impressions of a time long ago, the history of Cape Canaveral continues with each generation passing the baton to future generations. Dr. John Corbett and John Griffin of the National Park Service examine relics recovered by William and Florence Andrews. Corbett holds an ax head, and Griffin holds a silver cup. These items were found near present-day Pad 39B on the False Cape. (Randy Andrews.)

EVIDENCE OF THE FRENCH FORT? Florence Andrews shows artifacts to Paul O. Siebeneichen, NASA chief of community development. An archaeological survey stated that after construction began on the Kennedy Space Center, archeologist W. H. Andrews reported finding the remains of the French fort in the vicinity of Complex 39, near the beach. He said the site was destroyed by a railroad right-of-way, but he was able to find artifacts. The location of the reported site was marked by Andrews on the writer's aerial photographs as having been near the beach opposite Launch Pad 39B. (Randy Andrews.)

LIBERTY BELL RECOVERED. Gunter Wendt takes a turn at the podium after viewing the recovered *Liberty Bell 7* Project Mercury capsule, seen in the background. Curt Newport, right, led the expedition to find and retrieve the capsule. The expedition was sponsored by the Discovery Channel. Wendt worked on the *Liberty Bell 7* before its launch on July 21, 1961. After its successful 16-minute suborbital flight, the *Liberty Bell 7*, with astronaut Virgil "Gus" Grissom aboard, splashed down in the Atlantic Ocean. A prematurely jettisoned hatch caused the capsule to flood and a marine rescue helicopter was unable to lift it. It quickly sank to a three-mile depth. Grissom was rescued, but his spacecraft remained lost on the ocean floor until this salvage operation. Newport, an underwater salvage expert, located the capsule through modern technology and, after one abortive attempt, successfully raised it and brought it to Port Canaveral. The recovery of *Liberty Bell 7* fulfilled a 14-year dream for the expedition leader.

ANN THURM, CITY HISTORIAN. Thurm is the author of *The History of the City of Cape Canaveral and the Cape Canaveral Area*. She wrote two books on the history of Canaveral and has compiled five scrapbooks on the history of the city since its incorporation in 1962; these are on display at the Cape Canaveral Public Library. Thurm has served on various city boards and has been city historian since 1985. She believes it is important to pass history down through the generations. (CCC.)

HISTORIC ARTWORK. Mayor Rocky Randles shows a painting of Eberwein House. Artist Darleen Hunt captures on canvas a house of the Eberweins. The house was torn down, but its history is remembered. Otto Eberwein lived in this house; since Otto wasn't tall, the ceilings were not a standard eight feet but were only 6.5 feet. The wood of the house was "Merritt Island Mahogany" (actually Merritt Island pine heart). The core of the pine was a very hard wood that made it difficult to nail, but it paid off in that the house was never seriously damaged by any major hurricanes that often plowed through the area. (CCC.)

MARKING THE PAST. Located around Cape Canaveral, markers can be found indicating a time long gone. A modern monument dated 1984 designates the Cape Canaveral Air Force Station as a historic national landmark. Another more ancient stone marks a pauper's grave in the area of the city of Cape Canaveral. A shipwrecked seaman who swam ashore in 1884 and died shortly afterward was buried there.

JOHN GLENN SLEPT HERE. This Vernacular home was built by the Chandlers in the 1950s. When John Glenn was preparing for his historic launch, he would reside here as it was conveniently close to the space center. The house faces west on the Banana River and offers a beautiful view with breathtaking sunsets. (Roger Combs.)

INDEX

Across America, People are Discovering Something Wonderful. Their Heritage.

Arcadia Publishing is the leading local history publisher in the United States. With more than 4,000 titles in print and hundreds of new titles released every year, Arcadia has extensive specialized experience chronicling the history of communities and celebrating America's hidden stories, bringing to life the people, places, and events from the past. To discover the history of other communities across the nation, please visit:

www.arcadiapublishing.com

Customized search tools allow you to find regional history books about the town where you grew up, the cities where your friends and family live, the town where your parents met, or even that retirement spot you've been dreaming about.